IMAGES
of America

ST. IGNACE

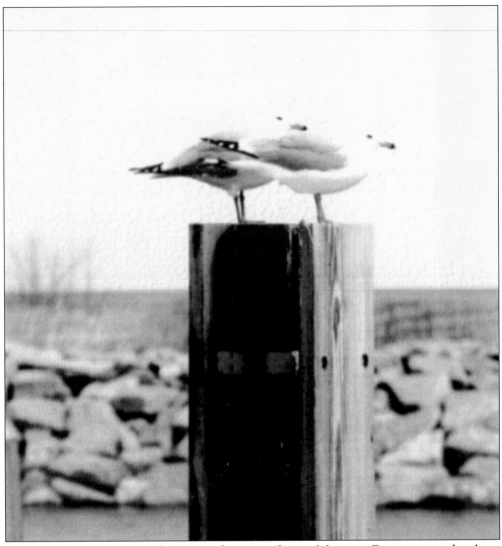

The gulls have been among the most enduring residents of the area. For centuries, they have followed the fishing boats in great swarms and enthusiastically invited themselves to join in all outdoor happenings. Gulls and other abundant waterfowl have been here to witness all the many layers of St. Ignace history. (Ruth LaChapelle.)

On the cover: Civil War veteran Simeon Snyder arrived in St. Ignace in 1879 and worked for a time as a carpenter. About 1887, he bought the hotel at the foot of Moloney Hill and named it Snyder House. It had rooms for 25 guests and a fine bar, with the best wine, liquor, beer, and cigars. Conveniently, a free rig met each train. In the 1915 cover photograph, Snyder (white mustache) stands beneath the mounted deer. A sign promises meals for 35¢, and a glimpse of the bartender can be caught through the window. Snyder's home was two doors north of the hotel, and he owned the livery stable directly across State Street. Snyder descendants have city hack license No. 545, issued to Snyder, allowing him to operate five hacks from May 1, 1896, to April 3, 1897, with an $8 fee paid. Dewey (Snyder's son) began waiting tables in the dining room at age 12 and was running the hotel five years later, in 1915. (Trude Thompson.)

IMAGES
of America

St. Ignace

St. Ignace Public Library

ARCADIA
PUBLISHING

Published by Arcadia Publishing
Charleston SC, Chicago IL, Portsmouth NH, San Francisco CA

Printed in the United States of America

Library of Congress Catalog Card Number: 2008928815

For all general information contact Arcadia Publishing at:
Telephone 843-853-2070
Fax 843-853-0044
E-mail sales@arcadiapublishing.com
For customer service and orders:
Toll-Free 1-888-313-2665

Visit us on the Internet at www.arcadiapublishing.com

This book is dedicated to the St. Ignace Civic League—they had the foresight to start the St. Ignace Public Library in 1924.

CONTENTS

ACKNOWLEDGMENTS

This book was written by a St. Ignace Public Library committee of Ryan Schlehuber, Linda Monville, John Monville, Ollie Boynton, Judy Gross, Hart Plumstead, Margaret Peacock, and Cindy Patten. The committee worked on this project for over six months. We tried our best to find pictures that had not been published before.

We thank Wes and Mary Maurer at the *St. Ignace News* for loaning Ryan to us, for their assistance on the book, and the use of their equipment. Judi Engle, from the Michilimackinac Historical Society, helped with historical information. Barbara Mullins-Zimmerman helped with writing captions. We thank Patti Boynton for her moral support and proofreading skills. The book *Before the Bridge* compiled by Emerson and Margaret Smith in 1957 was an invaluable resource for the written information in this book. Our book is not meant to be a complete history of St. Ignace, but a sprinkling of miscellanea until the 1970s.

Thanks to everyone in the community who provided the pictures. We could not have put this book together without you. Due to your generosity, we had so many pictures, we could not use them all. In addition to the pictures, we appreciate all of you whose memories and information assisted in completing the captions. We hope you enjoy your book.

INTRODUCTION

St. Ignace was named in 1671 when Fr. Jacques Marquette and the Jesuits arrived to set up a mission. Before 1671, the area was already a Native American settlement called Michilimackinac with a population of over 1,500. The Native Americans traded with the French for 30 to 40 years prior to the arrival of the Jesuit missionaries. Fort de Buade was established by 1688.

The first settlers were primarily of French descent. The French were initially involved in the fur trade and then the fishing industry by the 1850s. The Irish were the next to arrive, some prior to the Civil War. The 1880s and 1890s brought the Scotch, English, Swedes, Norwegians, Finns, and Germans for the lumbering and other industries.

St. Ignace was incorporated in 1882. Also in 1882, St. Ignace was established as the county seat and the first courthouse here was constructed. To the person unfamiliar with St. Ignace history, the astounding fact is that St. Ignace was a boomtown in the late 1800s. St. Ignace grew very quickly, and some predicted St. Ignace would be as large as Chicago and Detroit. The Martel Furnace Company alone employed over 250 people. The bay had many large docks filled with sailing and fishing vessels. Ferryboats made continuous trips along the coast and across the straits to meet the demands of people and business. The railroad docks were busy loading the steamships, and the shore was lined with hotels, boardinghouses, lumber mills, fish houses, and livery stables.

The St. Ignace area has been, and continues to be, a favorite tourist destination. The fresh water, clean air, natural beauty, and location make St. Ignace an easy vacation choice. The "Gateway to the Upper Peninsula" is a great place to visit and a great place to live.

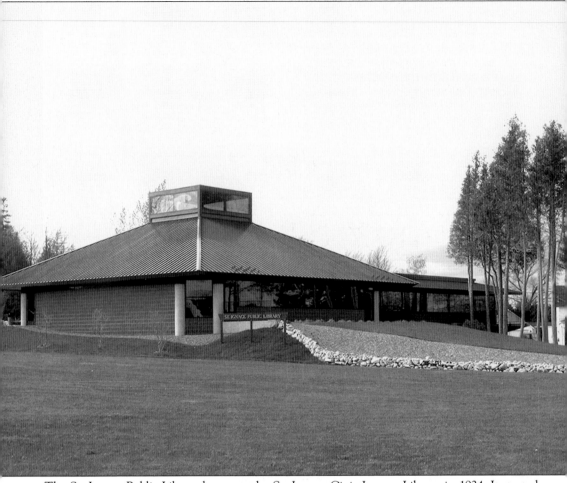

The St. Ignace Public Library began as the St. Ignace Civic League Library in 1924. It started with 100 books donated by civic league members and was housed in the old city hall. For a time, the St. Ignace Civic League Library was housed with the LaSalle High School Library. In 1940, the St. Ignace Civic League Library moved its 1,000 volumes into the new municipal building. In 1944, the St. Ignace Civic League stated the library was its most important project and formed a six-member library board. When the civic league disbanded in 1969, it turned the library over to the City of St. Ignace. In 1983, the library moved its 10,000-volume collection to the former Michigan Bell building on Spring Street. In April 2005, the St. Ignace Public Library moved to its new facility at 110 West Spruce Street. The new library, funded solely by grants and donations, more than doubled in size and now has a community room for library programs and community meetings. The new library has over 23,000 items in its collection and is operated by a seven-member library board. (Ryan Schlehuber.)

One

EARLY ST. IGNACE

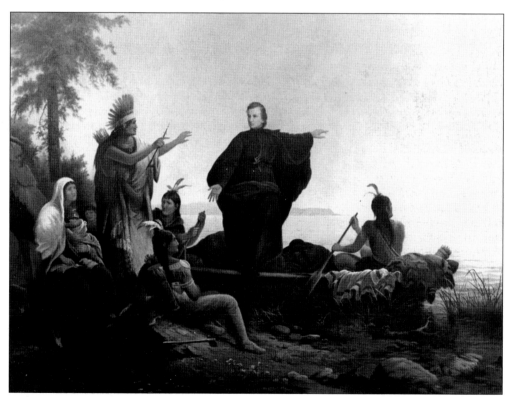

Father Marquette at St. Ignace in 1670 by William Woodruff Gibbs (1820–1902) was commissioned by William Spice, who operated the Russell House. In 1898, it appeared on a 1¢ United States postage stamp. The original 47-by-60-inch painting passed through several hands and for years was displayed in the Walker Funeral Home. It resides in St. Ignace still. (David Walker.)

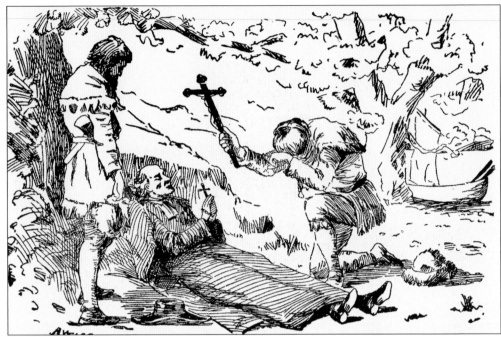

Fr. Jacques Marquette established a mission here and the name St. Ignace was given in 1671. In December 1672, Louis Jolliet and his party landed to take Marquette along on an exploration seeking the outlet of the Mississippi River in the spring. After their successful trip, Marquette stopped at the Green Bay mission and, being ill, stayed over the winter of 1674–1675. In spring, believing he did not have long to live, he began the return trip. He died en route and was buried on the shore near Ludington. Two years later, his remains were returned to St. Ignace by a group of mission Native Americans. His 30-canoe cortege was met at water's edge, on the site that is now Kiwanis Beach. The 1927 reenactment is pictured below. He was buried under the floor of the mission house. (Above, Michilimackinac Historical Society; below, Bob Nelson.)

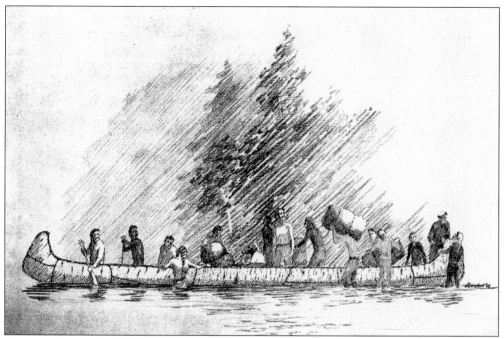

The French voyageurs, or coureurs de bois, left Montreal each spring in 30–40 foot canoes loaded with up to four tons of supplies and goods for trading. Paddling 12-hour days for months, they covered thousands of miles each season. To bypass rocky stretches, they unloaded and carried 90-pound loads of furs, goods, and the canoes. They trotted along the portage path until the canoe could be relaunched. (Michilimackinac Historical Society.)

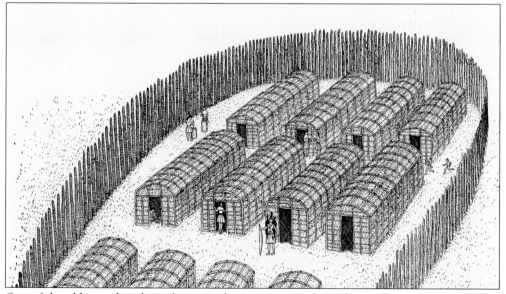

One of the oldest archaeological sites in the country is replicated in St. Ignace at the Museum of Ojibwa Culture. The Huron village longhouses are believed to have looked like this in the 1600s. The large multiple-family dwellings, up to 75 yards long, were constructed of poles covered with bark. Up to seven fires were kept per house, with one or two families sharing each fire. (Michilimackinac Historical Society.)

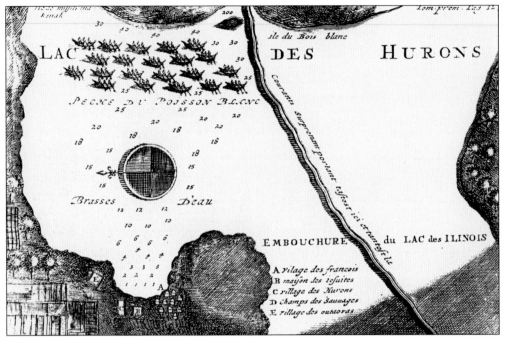

This anonymous 1717 map (north at left) shows the French village (A), Jesuit mission (B), Native American villages (C-E), and fields (D). The first fort at the straits, Fort de Buade (later Michilimackinac), was built near the mission before 1688, as a base for military expeditions attempting to eliminate English fur trading. Military authority ended here when the fort across the straits was built, shortly after 1715. (Michilimackinac Historical Society.)

French soldiers built this schoolhouse during the time that they occupied Fort de Buade. St. Ignace was an important outpost for the military, as were Quebec and Montreal. The school was later the home of Chief Sco-bo-gu-no-wis. This picture was taken around 1900, when it was probably 150 years old. The building was so deteriorated that it was torn down. (Deanna Draze.)

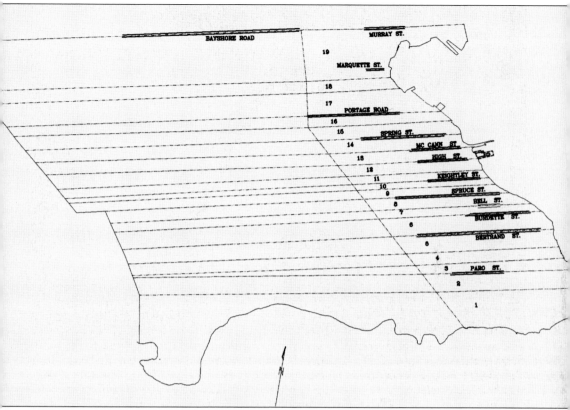

The French-era settlers were awarded farm grants, which were long narrow strips of land, each starting on the lakeshore. Lake frontage was important as a source of food and water and for shipping goods to market. Also known as ribbon farms, these private claims were secured by an act in 1807, which gave title to claimants who could prove they held their land prior to July 1796. These 19 private claims were surveyed in 1828 by the surveyor general's office. The very early claimants included Michael Jaudron, Alexis Lorrain, Jean Baptiste Perrault, Joseph St. Andrie, Joseph Gougneau, Augustin Hamlin, Jean Baptiste Bertrand, Pierre Muller, Pierre Carey, Jean Baptiste Tesseron, Ezekial and William Solomons, Luke and Joseph Chevalier, Francis Clairmon, Louis Babbien, Augustus Shabogen, Joseph Delvaire, Antoine Martin, Francois Trucky, Daniel Bourassa, and Francis LaPointe. Later claimants were Peter Hombach, Isaac Blanchard, Peter Hance, Amable Goudreau, Glout and Alex Charbonneau, Joseph Hobbs, and John Graham. These ribbon farms have long since been broken down into smaller parcels, but the private claim numbers still appear in abstracts and legal descriptions. (Mackinac County Equalization.)

Rabbit's Back Peak, a glacial formation, presents a view for many miles. Rabbit's Back served as an observation post for the Native Americans throughout the centuries. In the 1920s, the Rabbit's Back Resort "on the borderline between wilderness and home" owned by Charles Kerr and P. J. Short offered to rent a beautiful site "where Nature has done so much to please." (Deanna Draze.)

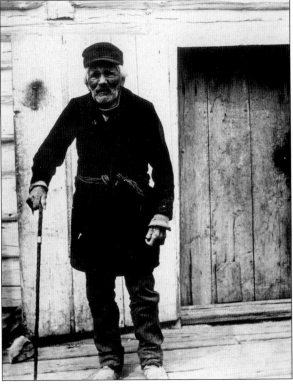

Chief Satigo, born around 1811, was a secondary chief at Michilimackinac. His settlement, located north of St. Ignace near M-123 and Mackinac Trail, was one of the last Chippewa settlements. There was a mission church and school at the site. Chief Satigo died in 1911 at the age of 100. (Michilimackinac Historical Society.)

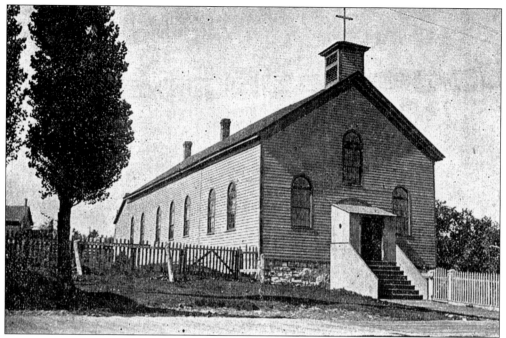

The old Mission Church was originally located on State Street across from the railroad dock. Built in 1837, it served as the Catholic church until 1904 when the present St. Ignatius Loyola Church was completed. In 1954, the Mission Church was moved to the site of Fr. Jacques Marquette's grave. (Phyllis Massey.)

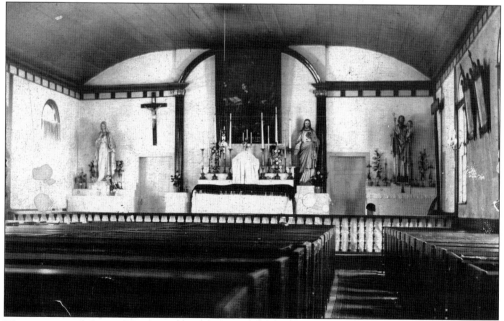

The interior of the old Mission Church was quite ornate even though the building itself was a very basic wooden structure. Bishop Frederic Baraga visited the church on several occasions as he traveled throughout the Upper Peninsula. The painting behind the main altar is titled *St. Ignatius Renouncing the World* and hangs in St. Ignatius Loyola Church today. (Florence Sturt.)

GULLS AT THE DOCKS ST. IGNACE, MICH. A·

This 1948 postcard features several fishing boats located near the Favorite Dock. As the fur trade declined, the French and Native Americans started fishing for their livelihood. The Swedish people who immigrated to the area were also heavily involved in fishing. By 1850, fishing had become a large industry. The lakes provided employment for many men who gave their whole lives to fishing. This area shipped thousands of barrels of fish at $10 each to Detroit, Chicago, Buffalo, and other ports. The most popular fish shipped were whitefish and lake trout. The massive amount of required barrels supported the cooperage trade. Of course, fishermen need many vessels, which encouraged the building of fishing boats. Some of the early fishing family names were Paquin, Gustafson, Carlson, Haffey, Reuben, Savord, LaJoie, Pond, Archambeau, Chenier, Grondin, Movalson, LaVake, Massey, Kerridge, Bolan, Vought, Holmberg, Blanchard, and Matson. (Shirley Bentgen.)

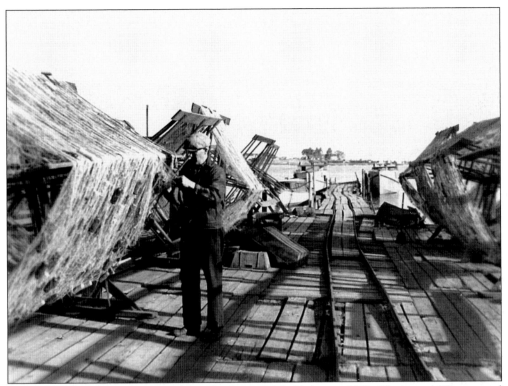

Hagen Fish Company was started by Charles and Jule Hagen in 1923. Their sons, Warren and Richard, continued in the business until the 1960s. It was located where the Old Fish House gift shop is today. A railroad car would bring the fish up to the company to be cleaned and packed. Fish that were not used locally were shipped out by rail or boat. (St. Ignace News.)

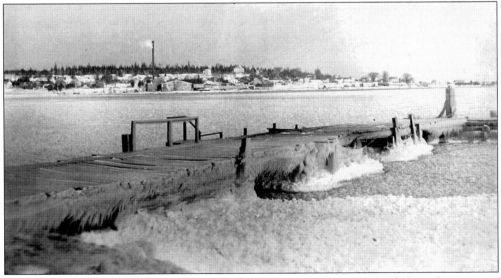

The McGregor Dock was located behind the McGregor gas station on North State Street across from Highstone's clothing store. Alfred Thibault ran boat cruises from this dock, taking groups at all hours of the day and night. Note the mill slip in the background and the Ryerse Tourist Home on the bluff. (John Hopper.)

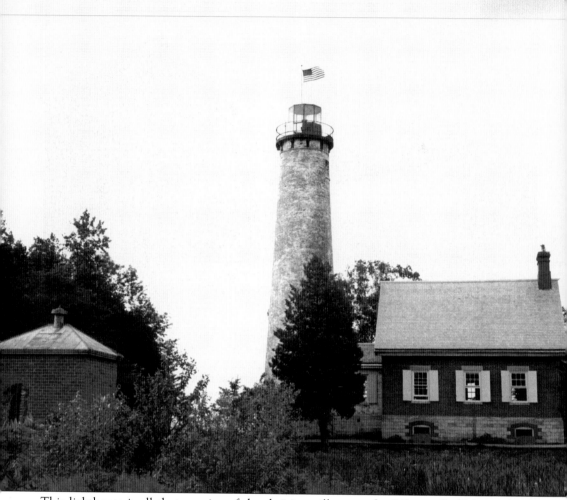

This lighthouse is all that remains of the thriving village on the 241-acre St. Helena Island. Brothers Archie and Wilson Newton (married to sisters of Frank Graham) bought the island from M. Belote about 1850. The Newtons had a store, a warehouse, and a dock to serve the shipping industry. Children from the mainland were boarded on the island to attend school. Louis St. Louis was one of the men who hauled wood across the ice to be sold as fuel for steamships. George Rapin and William Eddy worked at Newton's cooperage, making thousands of barrels to ship fish to Chicago, Buffalo, and eastern ports. Alonzo Cheeseman built boats for the Newtons. Thousands of pounds of maple sugar were shipped yearly. This was a good harbor, and up to 100 ships stopped each day. The lighthouse was installed in 1873 and had keepers until automated in 1922. Thomas Dunn was the first keeper, and later Capt. Joseph LaFountain kept the light for 20 years. John Easton, known as "the hermit," was the last to live on the island. (Michilimackinac Historical Society.)

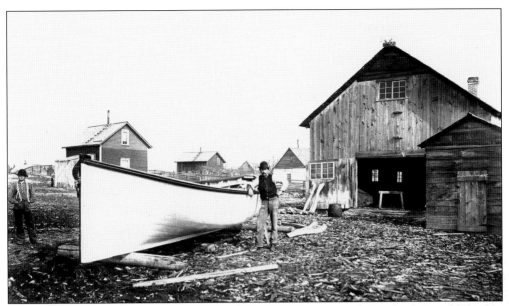

Some boatbuilders in this area were Alonzo Cheeseman on St. Helena Island, Ronald Rankin who built rowboats and sailboats, Joseph Derusha Sr., and the Chenier family. Ignace Chenier (center, above) and Jimmy Pond are seen with a newly built Mackinaw boat (near present Grondin Road). Some Chenier boats were for lighthouse duty—in 1893, they made one for Spectacle Reef Lighthouse for $260. *Edith Jane*, a Chenier 18-footer built around 1900, currently resides at State and Central Hill Streets. Mackinaw boats (below) were typically 14- to 34-footers (26 feet being the most popular). Their almost-flat bottom and shallow draft made them easy to beach where a dock was not available. They were used for fishing, carrying messages to steamships, and transporting people, freight, and mail. They were built until about 1915. (Above, Paul Grondin; below, Michilimackinac Historical Society.)

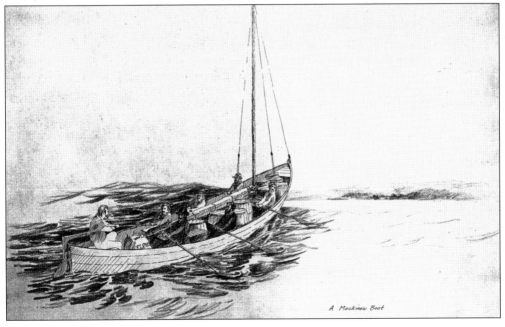

A Mackinaw Boat

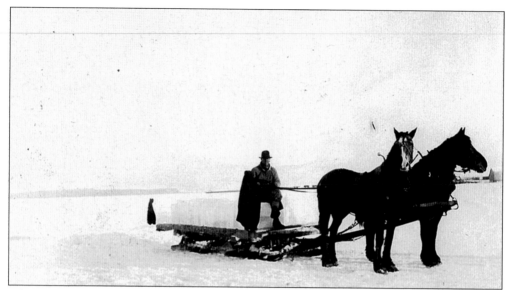

After the lake froze, the ice harvest began. Large blocks were cut in parallel lines and lifted out of the water. These were loaded onto horse-drawn sleighs (later trucks were used) to be hauled away. The ice cakes were packed into buildings with straw or sawdust between the layers and in the outside walls for insulation. Some of this ice was used locally, but most was shipped away. (Edwyna Nordstrom.)

This blacksmith shop, located near the Favorite Dock, was run (consecutively) by Tom Johnston, Tom Wilson, Charles Johnson, and Ed Glashaw (seen in the middle of the doorway). Other smiths were John McGregor (across from the current city hall), O. I. Rose, Robert Garrett, and John Beveridge (across from the end of Truckey Street). In 1915, blacksmith Thomas Johnson went through the ice and died bringing the mail from Hessel. (St. Ignace Public Library.)

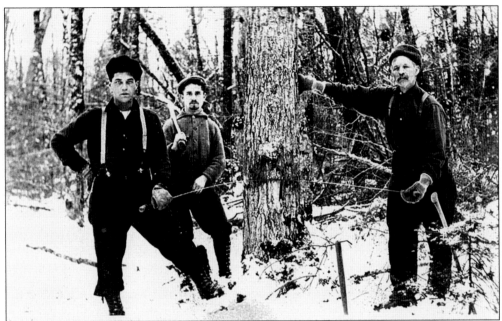

Lumberjacks sawed and chopped down pine and hardwood trees, some up to five feet in diameter and 200 or more feet high, clearing away the great forests. Horses hauled and dragged the logs on iced skid roads to be stacked at river's edge and branded with the lumbering company's log mark. When spring snowmelt filled the rivers with raging water, the logs were floated downstream into Lake Huron. In 1876, Mackinaw Lumber Company, owned by Otis Johnson and Francis Stockbridge, built the first sawmill in St. Ignace. This company also owned a boardinghouse, a company store, and a pier to ship lumber away on large schooners, all located in the (now) Stockbridge Street area. Some of these ships could carry 25,000 or more feet of lumber. (Above, Connie Mayer; below, Deanna Draze.)

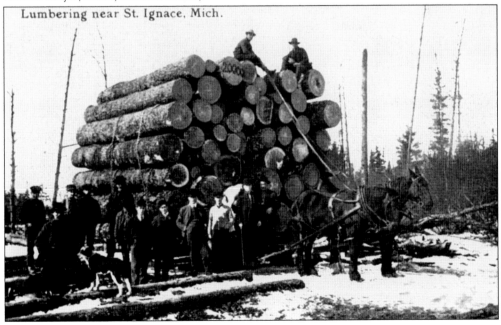

Lumbering near St. Ignace, Mich.

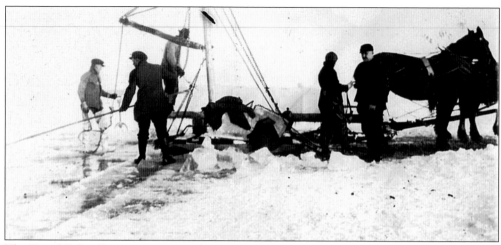

The Z and Z Ice Company put up a large quantity of ice during the winter of 1889–1890. In August 1890, the Central Railroad Company ordered Capt. Lewis Boynton to take *Algomah* (owned by the railroad) and tear away Z and Z's dock, claiming Z and Z leased the site from the railroad with the understanding that ice would only be shipped via rail. The captain found the Zeeder brothers armed and threatening to shoot anyone who interfered with the dock and he withdrew the *Algomah*. Returning around midnight, *Algomah* tore away part of the dock—but ran into and sank the scow *Kellogg*. (Edwyna Nordstrom.)

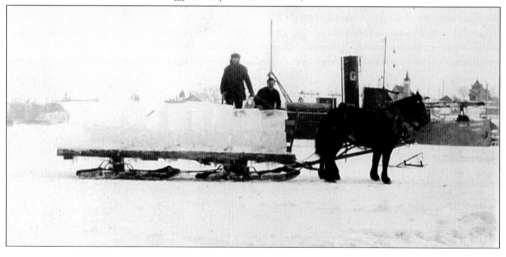

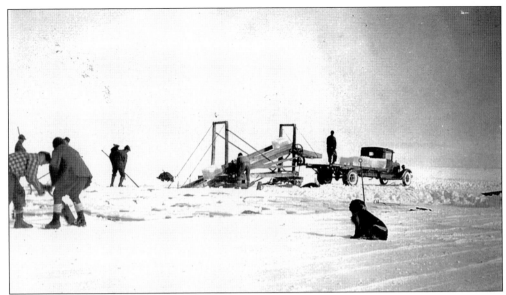

Shots were fired at the *Algomah* from the dock; no one was injured. The ice company promised to make trouble for the railroad over the *Kellogg's* sinking and because they claimed *Algomah* was running without lights. Capt. Lewis Boynton said *Algomah* had her lights burning as usual and that he pulled her bells and that he was ordered to do so by the railroad company. Twelve bullet holes were found in the *Algomah*. The Zeeder brothers and several others who took part in the shooting were arrested. The United States marshal soon arrived to serve the necessary papers. (Edwyna Nordstrom.)

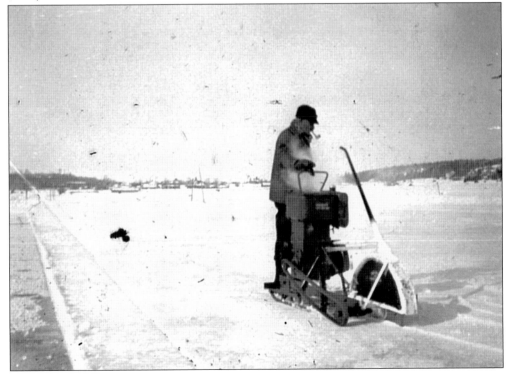

The forests provided wood for building materials, heating and cooking stove cordwood, barrel staves, telephone poles, railroad ties, fence posts, fuel wood to power steamships, veneer products, and wood to make charcoal for firing the ore smelters—all from this area. There were several sawmills in town through the years. Ed Lawson had a mill making net floats and fish boxes, near the present Kiwanis Park. The Mackinaw Lumber Company's facility was sold several times and used as a mill until the mid-1950s. That area is still called the mill slip. Standard Post and Tie Company operated on the Pavilion property beginning in 1918. (Tom Pfeiffelmann.)

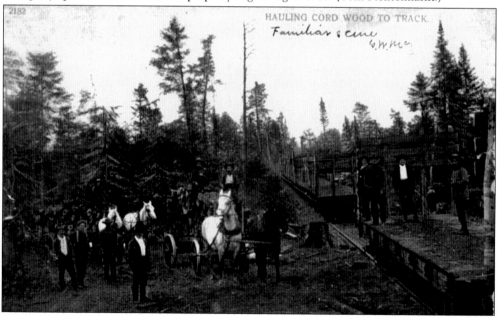

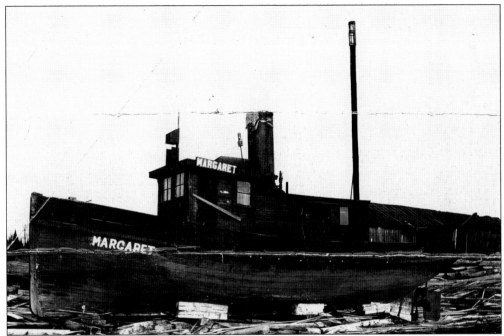

The Jamieson Lumber Company log boat *Margaret* (above) worked in the area of the Pine River Mill. John Jamieson also purchased—in partnership—the Mackinaw Lumber Company in 1892. Jamieson was civic minded, serving on the board of education and common council. While on the board of public works, he supervised the improvement of State Street. He was also instrumental in the adoption of a county road system. (Michilimackinac Historical Society.)

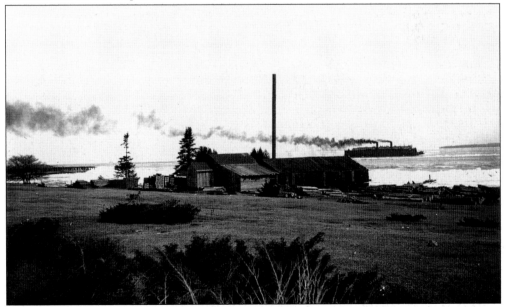

Lumbering was important in this area and gave birth to many wood-based businesses. There were at least two shingle mills in town. One was operated by O. J. Pitcher in 1896. Fred Shaver had a shingle mill on Graham's Point. This picture probably shows that mill, as Mackinac Island appears in the right background. (Michilimackinac Historical Society.)

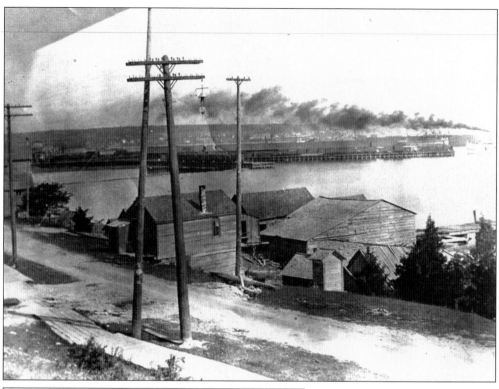

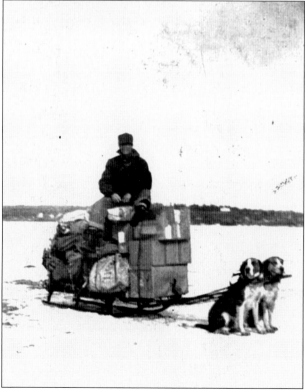

The first St. Ignace Post Office (1874) was on State Street at Hombach Street (above) with Peter Hombach as postmaster. Until 1929, when rural delivery began, everyone picked up their mail at the post office. Carrier service began in St. Ignace in 1946. Mail was carried on snowshoes, horseback, by dog or horse teams, and later, cars or trucks. In 1860, the gravel state road to the Soo was opened, with mail running twice a week. In 1915, Thomas Johnson went through the ice and drowned bringing mail from Hessel. Lloyd St. Louis and his dog team were also lost taking mail to Mackinac Island in 1937. At left are Isaac Paquin and his dogs on the way to the island with mail during the 1920s. The ice crossing continued to present problems until air service started. (Above, Ollie Boynton; below, Marie Quay.)

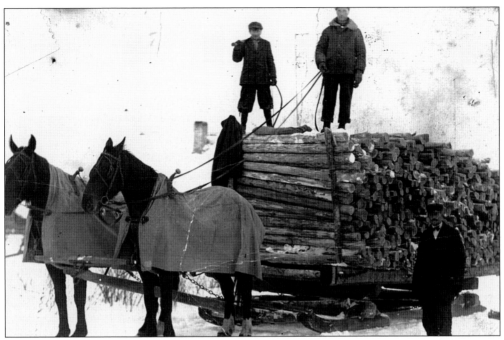

The blanketed team (above) is pulling a load of fence posts made by Standard Post and Tie Company. This enterprise, with Emil Albrecht as manager, began in 1918 and was located in the area of the Pavilion (near the corner of State and Hombach Streets). After logs were transported via rushing river water, they had to be sorted out and claimed by their rightful owners. To facilitate this sorting, an 1842 state law required each timber company to register its log mark in the county where the wood was cut. Every company branded each log on its end with one blow of a heavy marking hammer before the log left the woods. At right are log marks of Mackinac County area logging companies. (Michilimackinac Historical Society.)

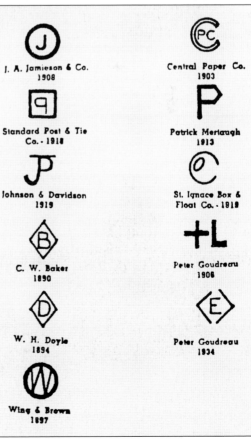

J. A. Jamieson & Co.
1908

Standard Post & Tie
Co. - 1918

Johnson & Davidson
1919

C. W. Baker
1890

W. H. Doyle
1894

Wing & Brown
1897

Central Paper Co.
1903

Patrick Mertaugh
1913

St. Ignace Box &
Float Co. - 1918

Peter Goudreau
1908

Peter Goudreau
1934

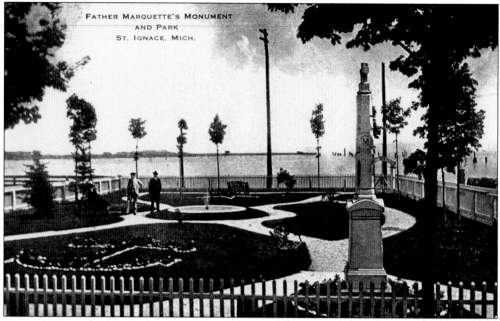

FATHER MARQUETTE'S MONUMENT
AND PARK
ST. IGNACE, MICH.

Pictured is an early depiction of Marquette Park. In the foreground is Fr. Jacques Marquette's grave marker. The marker was erected in 1882 and still stands in Marquette Park next to the old Mission Church (Museum of Ojibwa Culture). It continues to be a historic point of interest for visitors. (Phyllis Massey.)

In their heyday, 2,000 sailing schooners traveled the waters of the Great Lakes. The three-masted *Rouse Simmons* (in the foreground) was designed for the lumber trade. She sailed from 1868 until she, the crew, and her cargo of Christmas trees were lost in November 1912. She transported many different cargoes that were far more typical of Great Lakes trade: grain, lumber, logs, fence posts, bark, iron ore, and copper ore. (Jack Deo/Superior View.)

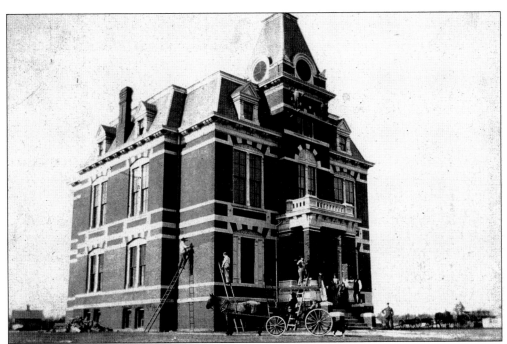

Under authority of Gov. Lewis Cass, Michilimackinac County was set up as a judicial district in 1818, with the first session in 1820. Early judges traveled from Washington, D.C., by foot, horseback, and sailing vessel. Court was held on Mackinac Island. Voters decided to move the county seat to St. Ignace. Sites were offered by several landowners. In 1882, for $25,000, the three-story redbrick Mackinac County Courthouse (above) was built at Portage and Prospect (now Marley) Streets. The courthouse included a basement jail, first-floor county offices, a second-floor courtroom, a judge's room, and two jury rooms. The third story was a residence for the undersheriff, as custodian of the building and grounds. Below are John McLeod and Isaac Corp (center) in the courtroom. The Mackinac County Board of Supervisors met in the courtroom also. (Above, Mimi Gustafson; below, Michilimackinac Historical Society.)

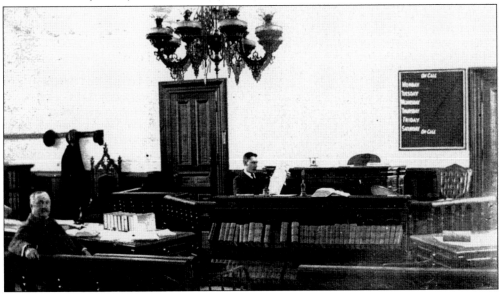

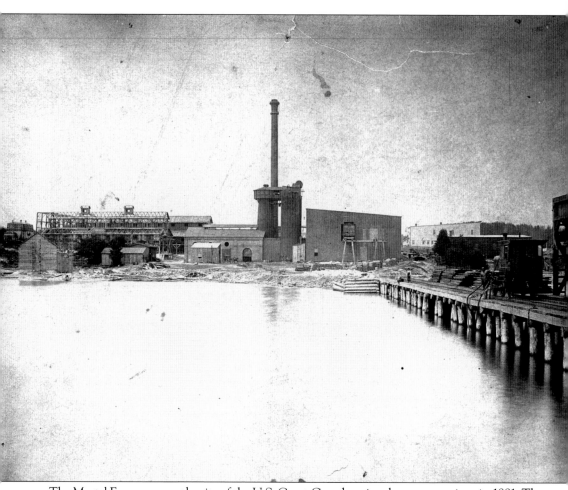

The Martel Furnace, now the site of the U.S. Coast Guard station, began operations in 1881. The furnace had its own dock, railroad siding, and retail store. The store was managed by Allan W. Hulbert. Ore was transported by rail from mines at Marquette. Martel was an open-hearth furnace, producing high-grade charcoal iron used to manufacture railroad car wheels. Martel owned timber operations at Ozark and Allenville with seven charcoal kilns. The railroad stop at the Pechta farm in Allenville was known as "First Kiln." Pioneers of Swedish origin came here to work at the furnace because of their knowledge of the smelting process. Among early employees were Daniel McNabb, Chester Carr, August and Charles Nelson, James Sorenson, Allan W. and son Allan G. Hulbert, and the company blacksmith, Thomas Goulding. About 1890, James Hough and W. B. Vance bought the Ozark timber operation; Vance later sold out to Hough. The furnace, a casualty of the financial panic of 1893, operated until 1894 and then sporadically for a few years until destroyed by fire in 1903. (Michilimackinac Historical Society.)

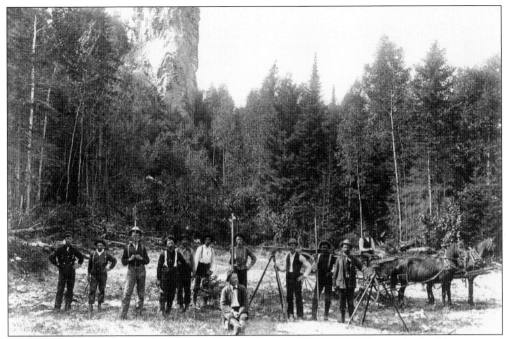

This picture shows surveyors and road construction men in preparation for building a road heading north. Notice Castle Rock in the background. The men are beginning the road north to Sault Ste. Marie, which was opened in 1860. This sand and gravel road allowed easier travel and enabled the mail to go north twice a week. (Mark Eby.)

Martel Furnace built a boardinghouse with a company store for its timber workers at Allenville in 1879. J. D. Erskine bought this building (left) in 1893 and opened a general store, with the post office inside. Next door is the Grange hall. In this photograph, heavy traffic is for the county fair being held in the field across from the store. (Michilimackinac Historical Society.)

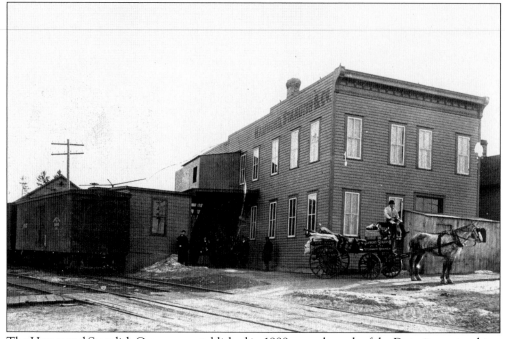

The Hammond Standish Company, established in 1888, was a branch of the Detroit meatpacking company of the same name. The building, located on High Street, had its own railroad siding for unloading its wholesale meat shipments. According to a *St. Ignace News* item dated October 22, 1892, the *Charlevoix* unloaded some 300 barrels of Chicago beef and pork at the railroad dock for Hammond, Standish and Company. (Wesley Maurer.)

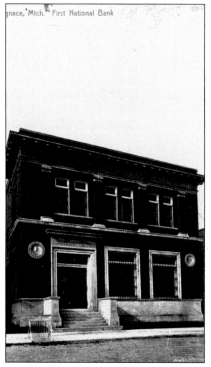

Early finances were handled by the government or privately. Otis Johnson and Sen. Francis Stockbridge's Mackinaw Lumber Company became the busiest financial brokerage. Buying out W. A. Burt's seven-year-old private bank, they formed First National Bank (1888) with capital stock of $50,000. Their first site was beside Wilber's Pharmacy, north of the present bank. Pictured is the second bank, built about 1902, just south of its present location. (Shirley Bentgen.)

Two

THE BOOM TIMES

The Colonial House was built as a residence by the Chambers family. Emigrating from County Mayo, Ireland, they prospered as businessmen, owned a dock, and held various county, township, and city offices. Michael was mayor of St. Ignace in 1890–1891. The site for this home was received from the St. Antoine family in exchange for a parcel of land in the current 900 block of North State Street. (Elizabeth Brown.)

Graham's Point was named for John Graham, who arrived here in 1817. It was also called Iroquois Point for the Native Americans who settled here. The group was attacked in a massacre that killed all but a few women and children. It was apparently a revenge attack by Native Americans from Gros Cap, led by Chief Saugeman. Graham's Point is located just east of the Mackinac Bridge. (Phyllis Massey.)

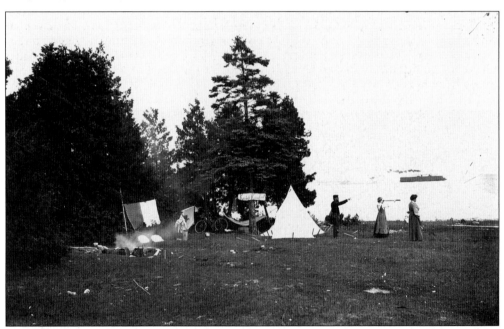

Some visitors did not choose to stay in local hotels, but preferred "roughing it." This campsite is well appointed with a tent, hammock, bicycle, campfire, and even its own name—see the sign, Kamp Komfort. These folks are watching boats on Moran Bay. Boat watching has been a popular pastime along the shore of Lake Huron for over 300 years. (Wesley Maurer.)

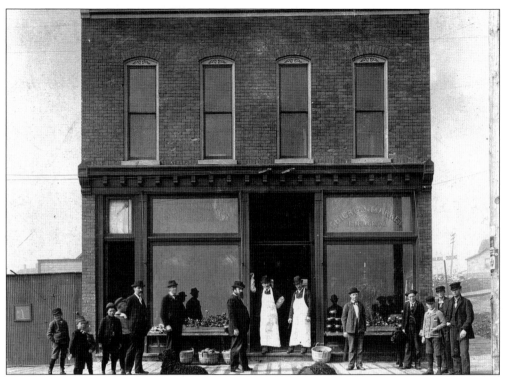

The Chicago Meat Market, at the corner of Spring and State Streets, was established in 1888 by Patrick Mulcrone and his wife. Wearing aprons (above), Archie Grant (left) and Patrick Mulcrone stand in the doorway of the shop. Patrick and his wife, Ellen (O'Donnell), came from County Mayo, Ireland, and migrated to Chicago. They owned a meat business there and thus named the store they established in St. Ignace the Chicago Meat Market. Note the hanging sides of beef and chickens and sawdust on the floor. This store offered produce, fish, flour, and other grocery items in addition to meat. The last owners of the store were Wayne and Michelle Pemble. The store burned down in February 1997. (Mike Lilliquist.)

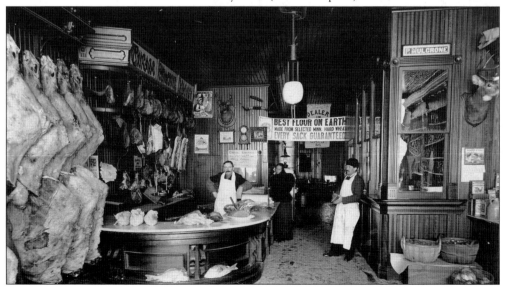

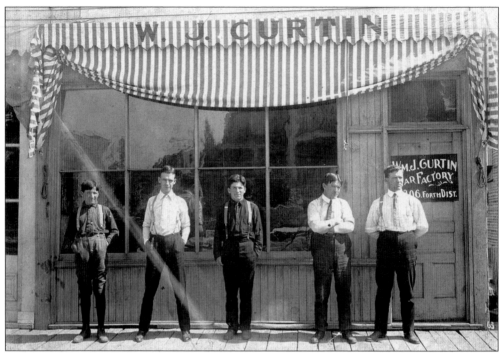

The William J. Curtin Cigar Factory was located on the lake side of State Street across from City Bakery at a time when the sidewalks were still wooden. Cigar stores were a popular place in many communities to socialize and hear all the latest news, possibly before it was published in the local newspaper. Bill Curtin and Jim Curtin White operated the store. (St. Ignace Public Library.)

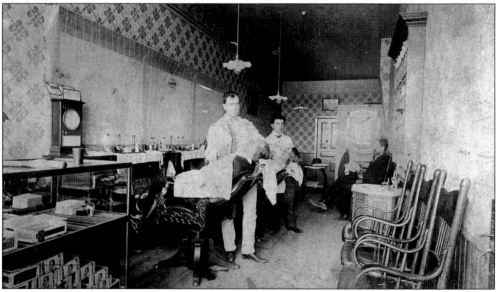

The two earliest barbershops were owned by Harry Wood and by Charles and Joseph Londraville, opposite the Globe (Dunham) Hotel, offering shaves for one dime and haircuts for a quarter. Later barbers included George Wixson (old Bank Building), William McCauley, and Leon Thibault (Mulcrone Block). These shops also offered tobacco, cigars, and baths. Hair dryers, electric face massages, and ladies' hair goods were added later. (St. Ignace Public Library.)

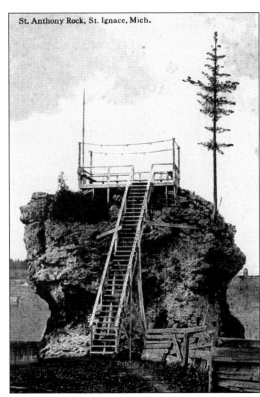
St. Anthony Rock, St. Ignace, Mich.

St. Anthony's Rock is one of many "sea stacks" located in the straits. It is made of breccia stone formed 350 million years ago from collapsed cave roofs. Glaciers melted 12,000 years ago, leaving lakes to wash away the softer stone around the stacks. Native Americans used sea stacks for lookouts, as approaching enemies were visible from miles away. Native ceremonials were performed on or near them as they were considered sacred. St. Anthony's Rock was also used as a concert bandstand (at right) in the late 1800s. It is said to have been named for St. Anthony of Padua by René-Robert Cavelier, Sieur de La Salle. It has also been called Goudreau Rock after a local family. Below is a side view of St. Anthony's Rock. (At right, Phyllis Massey; below, Tom Pfeiffelmann.)

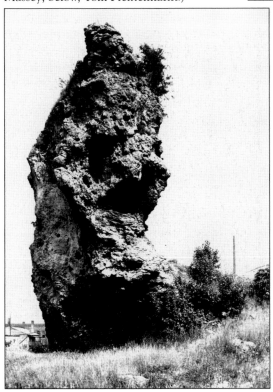

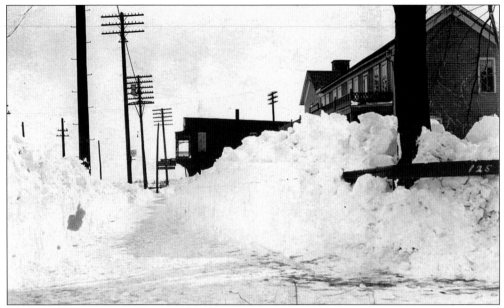

The Dunham House (between 1914 and 1921) is in the foreground of this view of State Street looking south toward Spring Street. Snow was not hauled away like it is today. The dark building on the corner of State and Spring Streets was at different times a restaurant, a grocery store, an ice-cream parlor, and an insurance agency. (Ollie Boynton.)

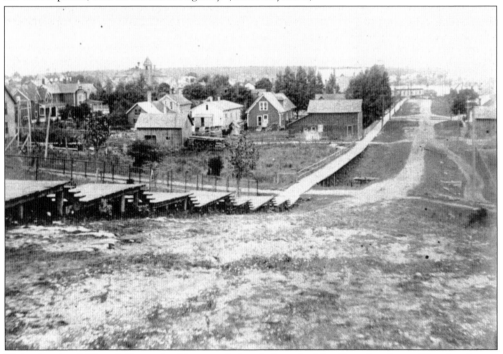

This view is of Church Street looking north just below the Ursuline Academy. The first house on the left is still standing and has been completely renovated. The Catholic church is at the end of the street. The tower of the old LaSalle School is visible on the horizon. Easing the walk down the steep hill are wooden stairs, railings, and a small bridge. (Ollie Boynton.)

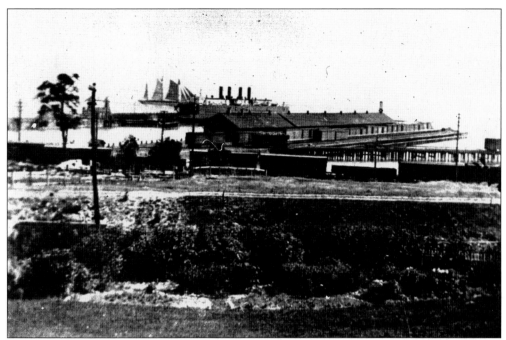

The merchandise dock, straight out from High Street, was a busy place. Vendors sold newspapers and goods to tourists, freight was loaded and unloaded from trains, and excursion steamships landed or departed. At one time, there was a footbridge over the water connecting this dock to the passenger dock for transferring passengers. The *Sainte Marie I* and a ghostly three-masted schooner can be seen in the background. (Chris Bloswick.)

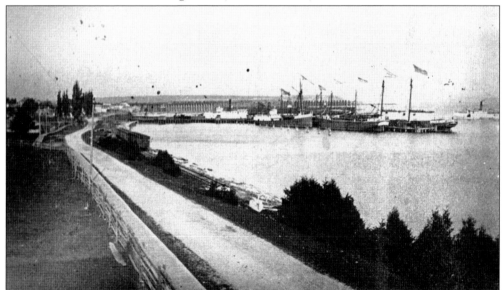

This is South State Street looking north from about Hombach Street. Closest is the merchandise dock, with at least seven sailing ships. Next, north, is the railroad dock. A ferry steams in from the far right. Between the street and shore is a dead-end railway spur used to park spare railroad cars. The boxcars shown here are in the present American Legion Park at the State Street wye. (Ollie Boynton.)

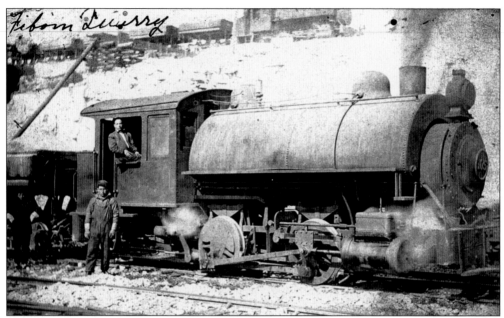

Fibron Quarry operated from 1909 until 1935 in Hendricks Township, about seven miles west of Trout Lake. Fibron's limestone was loaded as chunks onto ore railcars headed for the crusher. Taken by conveyor belt to the loading building, the crushed limestone was deposited into four railcars simultaneously. The crushed limestone was then taken about four miles to the Duluth, South Shore and Atlantic Railway (DSS&A) main rail line. (Michilimackinac Historical Society.)

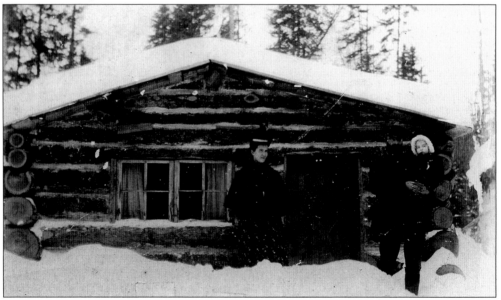

P. M. and Anna McCann Furlong stand in front of their lumber camp cabin in Hendricks Township, west of St. Ignace, in 1897. P. M. is holding their firstborn, F. P. "Pat," who was also later in the timber business. Lumber cutting was done in the winter, and horse-drawn sleds were used. The men were at camp for weeks, but strayed on payday to the nearest town and tavern. (Hart Plumstead.)

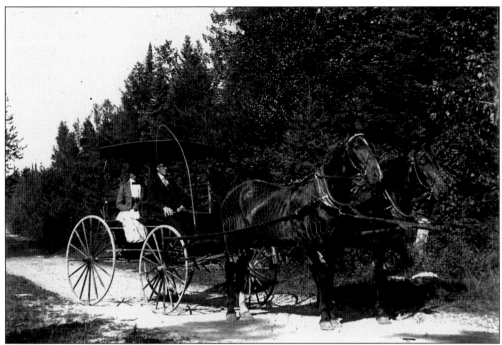

Visitors to the area could hire a carriage and driver for local sightseeing. This well-appointed rig and team, complete with decorative fly nets, are heading to view Castle Rock. Other popular destinations were Rabbit's Back, St. Anthony's Rock, Fr. Jacques Marquette's grave, a shore drive along Boulevard Drive to Gros Cap, the old fort trenches on the bluff, and views of the St. Martin's, Mackinac, St. Helena, Bois Blanc, and Round Islands. Felix Paquin and Harvey Clarke were two of the drivers who would meet visitors at their boat or hotel for a tour. Horses were important to early settlers . Until into the 20th century, they helped in almost all work done by people everywhere. They were companions in recreational times also. This young girl (below) is driving her sulky and handsome pony. (Above, Mary Lou McKinnnon; below, Wesley Maurer.)

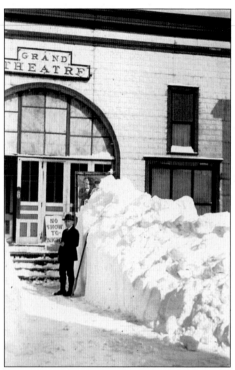

Charles Kynoch Jr. stands in front of the Grand Theatre, which offered motion pictures and live shows (located in what is now a parking lot north of Arnold Dock). In December 1916, Clarence Eby was hired as manager. In January 1917, the Grand burned. The day of the fire, Kynoch renamed the Butterfly Theater the Midget Grand and the show went on. The original Grand was never rebuilt. (Edwyna Nordstrom.)

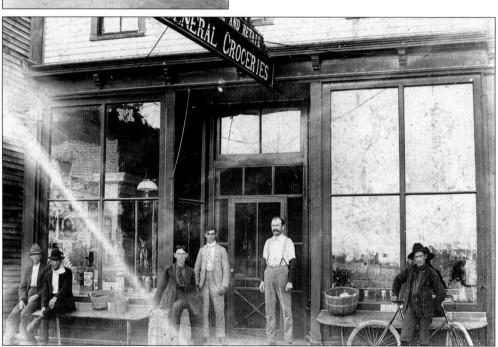

The Massey Brothers Grocery Store, located in the Third Ward, operated in the late 1800s. The Masseys were an early St. Ignace family that settled in the north end of town. This was a time in St. Ignace history when many businesses were booming and St. Ignace was growing by leaps and bounds. This is the era St. Ignace became known as the "Gateway City." (St. Ignace Public Library.)

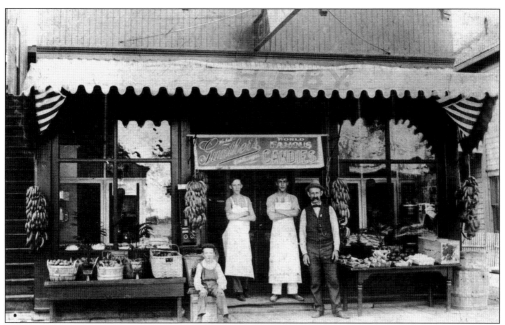

Charles H. Eby (wearing hat) stands in front of his City Bakery in the 1880s with two of his aproned employees. The shop offered much more than baked goods: candy, produce, groceries, and huge bunches of bananas. Located just north of LaRocque Drug Store, the shop changed hands over the years to Fred Goudreau, the McLaughlins, and now houses Mackinac Properties. (Billy LaRocque.)

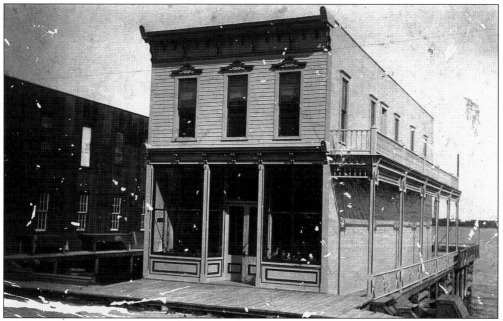

This building, known as the Quay Building, sat across from the present First National Bank. The area is now a parking lot for Arnold Line. The Quay Building originally had Texaco gas pumps in the front. Owners are thought to have been Edward and Ida Quay, who dealt in petroleum products. (Mario Calcaterra.)

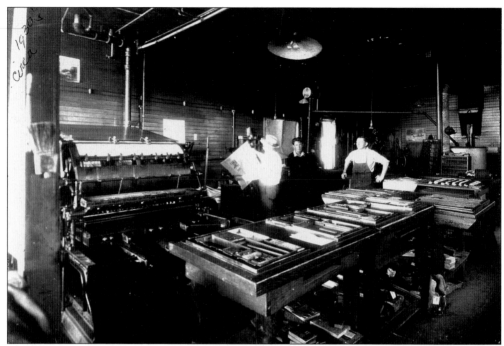

Above is the inside of the *St. Ignace News* building located next to the First National Bank on State Street. Pictured are, from left to right, Ed Chatelle, Vincent Goudreau, and Ralph Backie. The *Republican News* was purchased by Ed Chatelle (pictured below) from P. D. Bissell. Ed's son, Welden Chatelle, ran the paper for many years after Ed's death. The first newspaper, the *St. Ignace Republican* (later changed to the *Republican News*), was established in 1878 by P. D. Bissell. For a time, there was more than one newspaper in town. The *Enterprise*, established by Ed Jones in 1894, was published for nearly 40 years until it was sold to the *Republican News*. The *Watchman*, established in 1886 by George Hombach, was published only a few years. (Edwyna Nordstrom.)

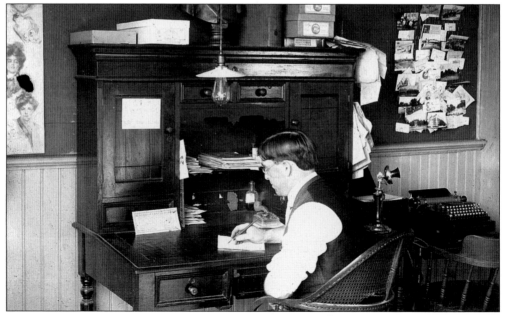

Walker Furniture was founded in 1880 by Eli Mallett and his son-in-law Frank A. Walker. Under the name Mallett and Walker, the business also included undertaking services. Louis P. Walker carried on until 1960 when Leila Walker became owner and continued the business with sons, Ronald and David. A new store was built in 1970. David continued the business through its 125th year. (Shirley Bentgen and David Walker.)

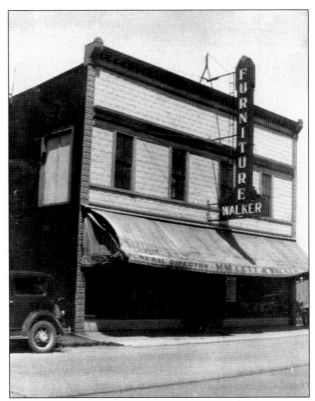

This view is looking down from Truckey Street in the late 1920s. The business is Ray's Motor Sales, owned by Ray McLachlan. John Ruegg, McLachlan's son-in-law, bought the business from him, and it became a Firestone store. In the 1950s, it became the Ace Hardware store. Today the Ruegg family still operates the Ace Hardware. (Rae Tamlyn.)

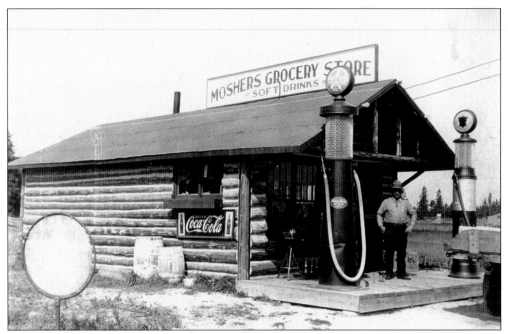

Mosher's small grocery store and gas station was located in Evergreen Shores near the present Pines Trading Post. The Moshers sold the store to Bill and Yustina Ferris. Note the two vintage gas pumps. The pump on the left sells White Star Gasoline. The one on the right is unidentifiable. The round advertising sign on the left features Staroleum Motor Oil. (Bob Nelson.)

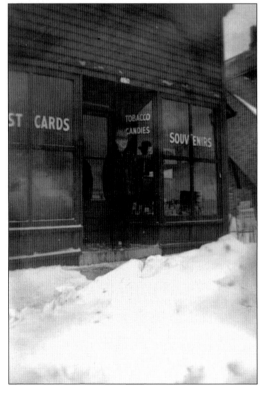

Don Vigeant came to St. Ignace in 1887 and operated the Yellow Front novelty store across from the depot. With all the railroad activity, he did a good business selling tobacco, candy, souvenirs, and fishing supplies. He lived in the former Boynton home on McCann Street and eventually traded houses with George Davis on South State Street. George Davis then established the Davis Funeral Home on McCann Street. (Ollie Boynton.)

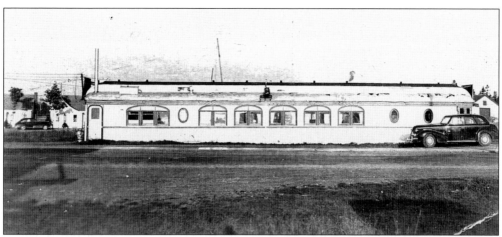

Fred and Violet Bye set this Pullman car up as a bar, with tables and booths (below), situated parallel to State Street at the site of the current Driftwood parking lot. It was sold to Emil and Adelaide Syverson in the late 1940s. Later they removed the Pullman, built the present building, and added cabins and a motel. In 1958, the business was purchased and remodeled by Louis and Amanda Yellin and renamed Danny's Bar. The motel stayed, but the cabins were moved to a new location. Another Pullman was used as a bar farther north on State, in the area of Paquin and Hazelton Streets. This was Sy Nelson's Pullman Palace. (Velma June Gustafson.)

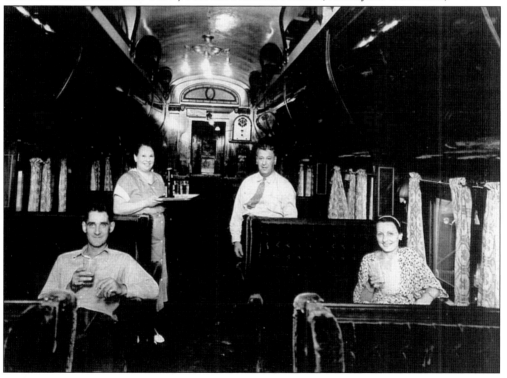

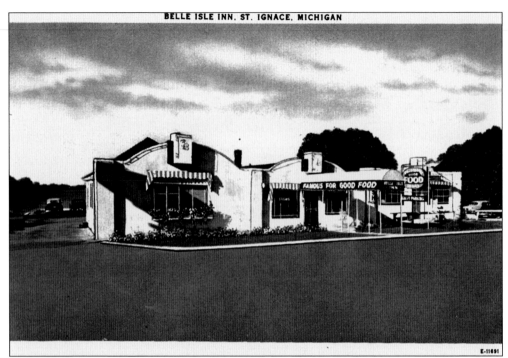

The Belle Isle Inn became famous for fine dining under the ownership of Al and Monica Belisle. Their whitefish dinners brought many people to the restaurant. At one time, the left side was Lazy Bob's Fish Market, then Chester Taylor's Fish Market. The Belisles later made the whole building into the Belle Isle Inn located where the Galley Restaurant is now. (Vic and Mary Swiderski.)

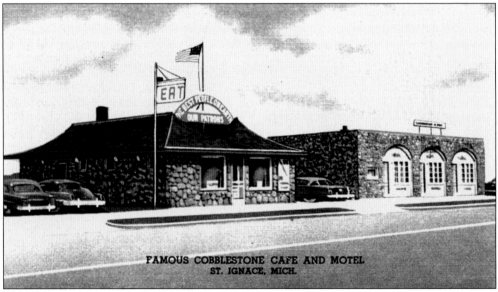

The Cobblestone Café was built and operated by Ed and Ida Quay in the 1930s. For a few years the south side was a garage. Later the garage was made into three hotel units. Don and Marion Vaughn bought the restaurant in the late 1940s. The unique-looking building was located just south of Indian Village on the lake side of State Street. (Phyllis Massey.)

48

Three

TOURISTS COME TO THE GATEWAY CITY

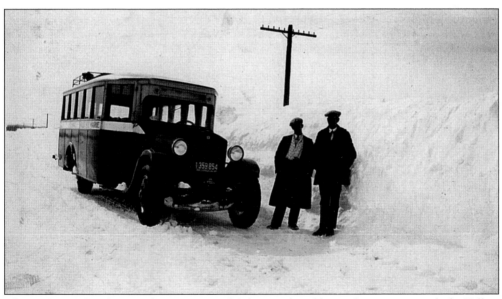

The McGregor brothers, Seth, Duncan, and Adam, replaced horse-drawn stages with the Yellow Bus in 1922. Passengers could travel to Sault Ste. Marie, Cedarville, Hessel, and Pickford. Just getting to Hessel took three hours. Additionally, beginning in 1923, mail was carried to the Les Cheneaux area during the winter, until the ice thawed to allow navigation. The brothers also operated McGregor Oil Company. (James Gustafson.)

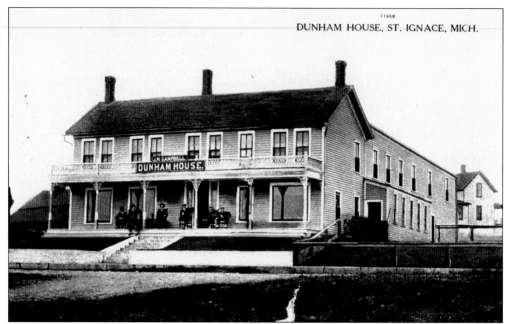

Accommodations were available just north of the merchandise and railroad docks, near the corner of State and Spring Streets. Prior to 1885, L. H. Dunham's Dunham House offered 25 rooms. In 1885, James Campbell and his wife bought it and built a 30-foot addition six years later (above). The Campbells offered a full dinner for 25¢ in those days and kept the hotel until selling out to C. H. Stannus in 1912. Extensive alterations expanded the Dunham in 1914, adding six guest rooms, a fireplace, steam heat, and enlarging the dining room. The next transfer (1921) was to O. P. Welch and Valentine Hemm, who also owned the LeClerc Hotel (below) next door. The three-story LeClerc, with 75 tourist rooms, had formerly been named both the Everett House and later the Russell House, owned by William Spice. (Above, Phyllis Massey; below, Deanna Draze.)

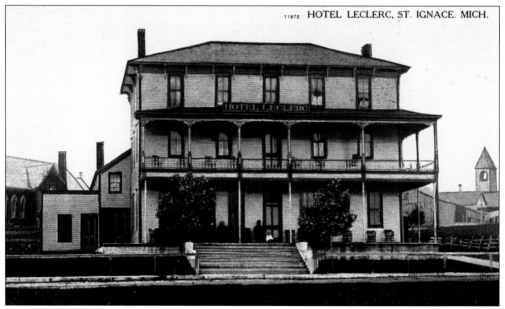

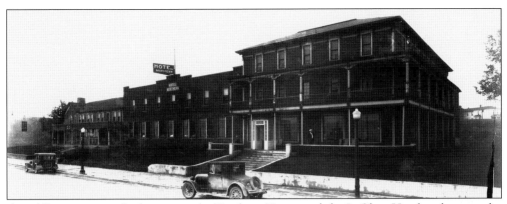

A middle section was built, joining the Dunham House and the LeClerc Hotel, to become the Hotel Northern (above), in 1921. A 1925 advertisement states that 84 guest rooms—27 with private baths—were available at $1.50 to $3.50 per day. The Northern also offered a large dining room (below), café service on the porch, and a spacious lobby, ballroom, and billiard parlor, with views overlooking the straits. This hotel, later renamed the Nicolet Hotel, was located on State Street between Spring and Truckey Streets. By 1942, the Dunham portion was being used as a commercial laundry. In May of that year, the Nicolet Laundry was destroyed by fire. The firefighters saved the concrete middle and LeClerc portions. The Nicolet Laundry was later housed in the new metal Quonset hut erected on the old Dunham site. (Above, Keith Massaway; below, Deanna Draze.)

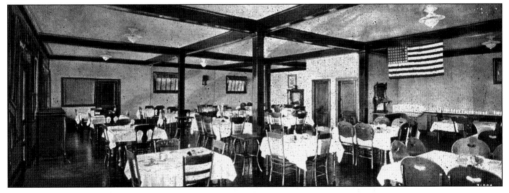

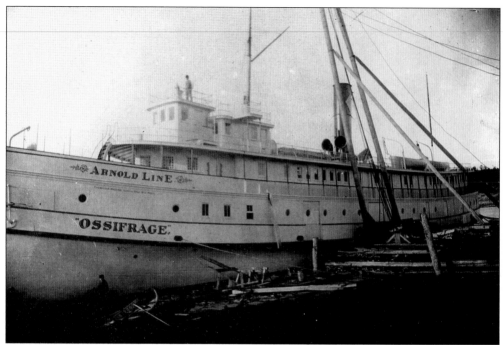

At first, ferry service was carried on along the shore to serve lumber camps and fishing points. Among these early boats were *Mary* (1870), *Gazelle*, *Lotus*, *Waukon*, and Mulcrone Brothers' *North Star* and *Columbia*. The 123-foot *Ossifrage* (above) was built in 1886. The first *Chippewa* (below), formerly the iron-hulled U.S.S. *Fessenden* (last revenue cutter on the Great Lakes), was built in 1884. Both of these side-wheel steamers were brought here by George Arnold to transport passengers, mail, and freight on his coastal routes. Some others that were used on these runs and to Mackinac Island were *Elva* (former gospel ship *Glad Tidings*), *Saugatuck*, *Martell*, *Minnie M.*, *Faxton*, *Iroquois*, and *Charles McVea*. Arnold Line continued the coastal trips until 1920. (Above, Michilimackinac Historical Society; below, Bobby Brown.)

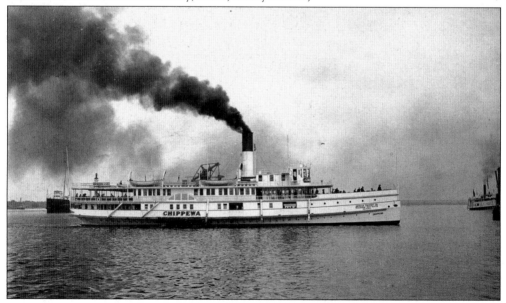

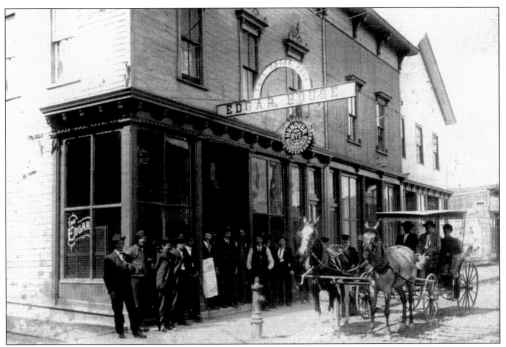

One of many hostelries, the Edgar House started life as the Globe in 1881. Offering rooms, as well as refreshments (below), it was owned by Thomas Edgar (1864–1910). Unfortunately and in spite of the conveniently located hydrant, it succumbed to fire in February 1908. This was the biggest fire in St. Ignace up to that time. It consumed not only Edgar's business but the opera house and several other stores near the corner of State Street and Central Hill. The firemen fought the blaze for hours in near-zero temperatures and a blinding snow blizzard. They did manage to save the Murray Brothers store across the alley. (Margaret Hill.)

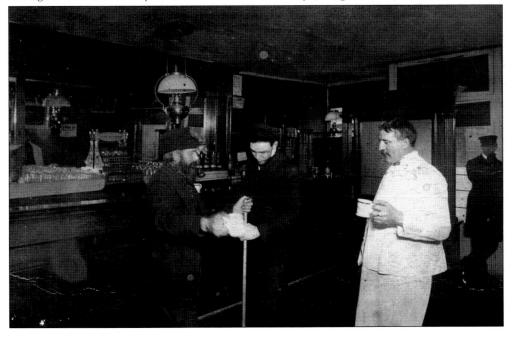

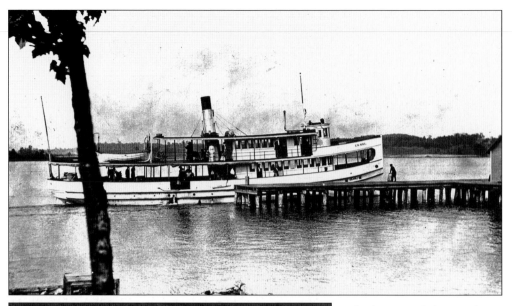

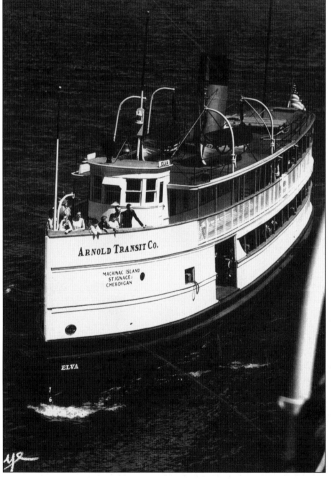

The last gospel ship, 70-foot *Glad Tidings*, built in 1889, was sold to James Keightley in 1896. She was immediately renamed *Elva*. Keightley partnered in ownership with George Arnold two years later. She was refitted with two new decks and lengthened to 90 feet (above) in 1904. *Elva* traveled the St. Ignace, Mackinac Island, and Sault Ste. Marie route until 1922 when she was sold. Repurchased the next year, she ran the Bois Blanc, Cheboygan, Mackinaw City, St. Ignace, and Les Cheneaux route from 1923 to 1939 (at left). Converted to a flat-top barge in 1944, she hauled supplies to Mackinac Island until 1953. As part of the Mackinac Bridge groundbreaking ceremonies, Arnold Transit decided to burn the boat, but weather prohibited this. On May 11, 1954, she was burned and sunk four miles off Mackinac Island's Arch Rock. (Bobby Brown.)

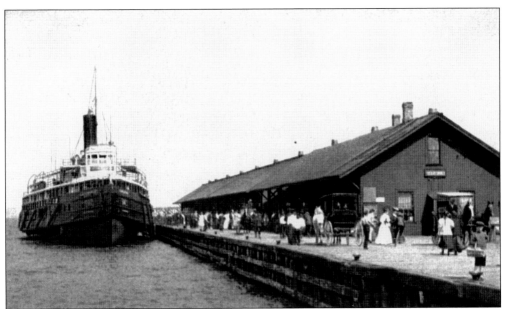

A Detroit and Cleveland Steam Navigation Company (D&C) steamship arrives at the merchandise dock (above). The steamers *City of Alpena*, *City of Mackinac*, and *City of St. Ignace* (below) made two trips per week in spring and fall, between Toledo, Detroit, Mackinac Island, and St. Ignace, and four weekly trips in summer, from 1882 until 1920. The D&C operated the only iron and steel side-wheel steamers on the Great Lakes. These boats were fast and carried hundreds of passengers and tons of freight on each trip. There were also routes to Chicago, around the Upper Peninsula, and to other Great Lakes ports. Connections were available with the DSS&A, for fast, inexpensive travel to Lake Superior points. The D&C published a guidebook for trip planning and local points of interest. (Above, Phyllis Massey; below, Michilimackinac Historical Society.)

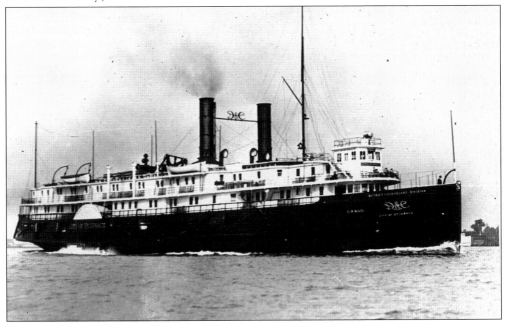

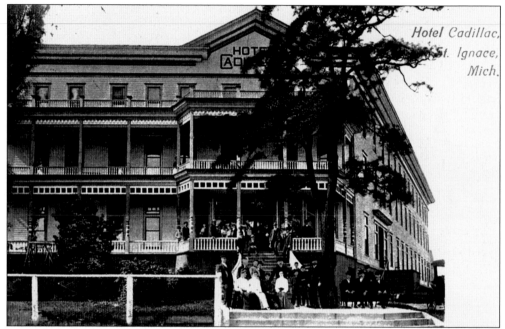

Hotel *Cadillac,*
St. Ignace,
Mich.

The Cadillac Hotel was built in 1888, the same year the ice crusher *St. Ignace* arrived. It was at the corner of State and High Streets across from the merchandise dock where the railroad passengers disembarked. The Cadillac was first called the Sherwood House, named after Eleazer Sherwood, father of Ella Fair. The Cadillac, which burned in 1911, had a large dining room and 200 rooms. (Deanna Draze.)

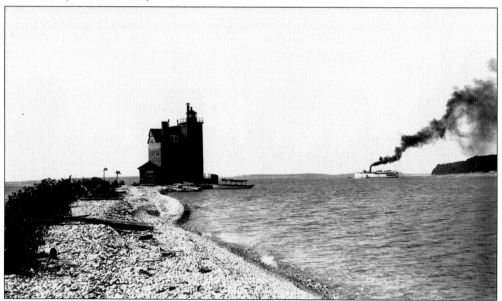

Local contractor Frank Rounds built the Round Island Lighthouse in 1895 at a cost of $15,000. After being decommissioned by the U.S. Coast Guard in 1947, time and weather took their toll. A whole corner collapsed in a 1970s storm, and preservationist groups stepped in. By 1980, restoration of the lighthouse exterior, the oil house, and the outhouse was complete. (Michilimackinac Historical Society.)

Simeon Snyder (fifth from left, about 1907) changed his hotel's name from Snyder House to Central Hotel (there was an earlier Central Hotel at State and Central Hill Streets). The family continued running the Central after Snyder's 1917 death, until it closed in 1925. Standing empty until 1939, it was razed along with the Snyder home and two store buildings for the new municipal building. (St. Ignace Public Library.)

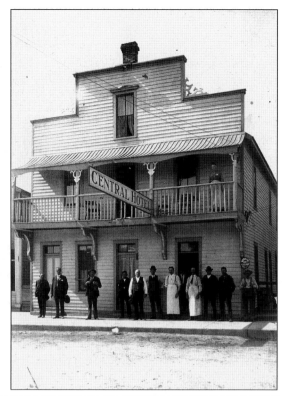

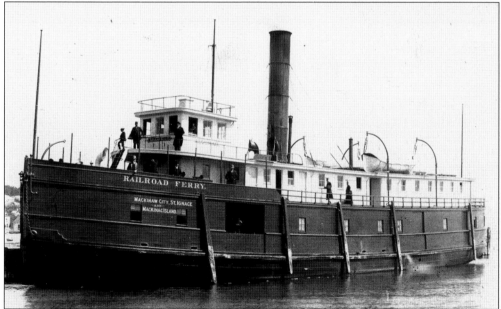

The *Algomah*, a bulk steamer, was purchased by the Mackinac Transportation Company in 1884. She was 127 feet long and was used to push the barge *Betsy*. *Betsy* held four railroad cars. The cars were exposed to the weather because *Betsy* was not covered. This barge was hard to control in the rough waters and ice of the Straits of Mackinac and was only used for four years. (Ollie Boynton.)

Arriving at the railroad depot and looking toward town, the Catholic church steeple and LaSalle School bell tower are just right of the closest utility pole. The train at left is headed onto the south side of the merchandise dock or will be parked on the dead-end spur (now American Legion Park). (Superior View.)

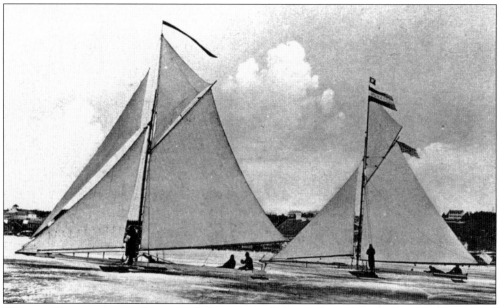

Winter sailboats were raced on a track from the mill slip to the ore dock. Pete Truckey owned one of these champion iceboats. Aubrey Fitch, later vice admiral in the United States Navy, is said to be on one of the pictured iceboats. Capt. John McCarty piloted his iceboat from St. Ignace to Mackinac Island in eight minutes, "including stops at the cracks," in February 1892. (Jack Deo/Superior View.)

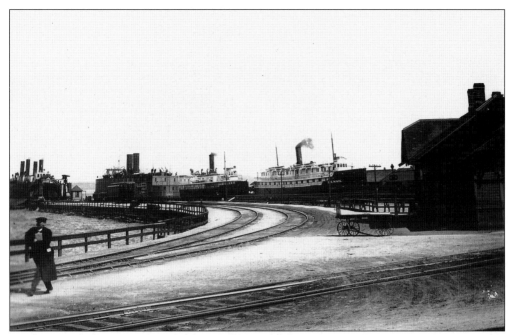

A baggage cart sits in front of the original depot (right). Left to right are railroad ferries *Sainte Marie I* and *St. Ignace* and two D&C passenger steamships at the merchandise dock. A Pullman and a boxcar wait near the ferries. The nearest track goes to a dead-end spur used to park extra cars and to the merchandise dock. The depot was across from the end of McCann Street. (Rae Tamlyn.)

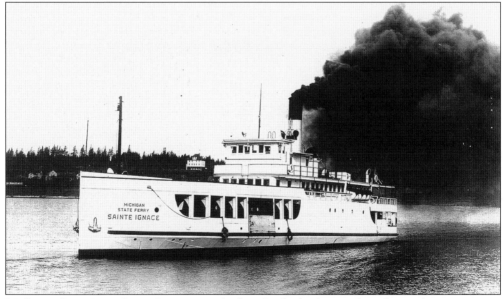

Michigan State Ferry *Sainte Ignace* is in the bay. In the background is a large white cottage on Ryerse Hill. It was called Sco-Bo-Go-No-Wis after the chief who lived on the spot for a time. He was believed to be French–Native American and to have started the sugar bush at Indian Village. Lewis Ryerse rented out rooms with views of Mackinac Island and Lake Huron here. (Ollie Boynton.)

Newspaperman Edward Chatelle's family stands in the yard of their home on Truckey Street. Two have their bicycles at the ready. Bicycle riding became popular in the 1890s, and G. H. Veldhuis operated a bicycle store in town. Some members of early bicycling clubs were Charles Mulcrone, C. G. Agrell, Harvey Jones, Fred Shaver, Ray Boynton, W. H. Culver, John Bell, Emil Johnson, George Elder, George Litchard, and P. Heffron. (Edwyna Nordstrom.)

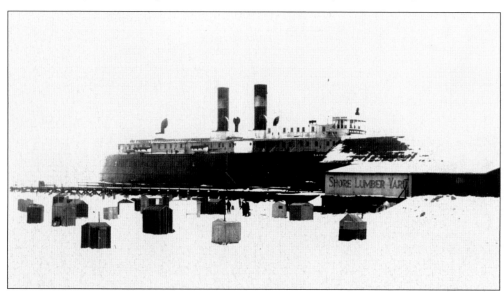

Icebreaker *Sainte Marie II* was built in Toledo in 1913. The engines from *Sainte Marie I* were installed in *Sainte Marie II*. She had a 14-railcar capacity and was mainly used as a spare boat. The Michigan State Ferries and Lake Carriers Association used her to break ice until 1952. The ice fishing for perch was excellent in the 1940s and 1950s in the bay. (Ollie Boynton.)

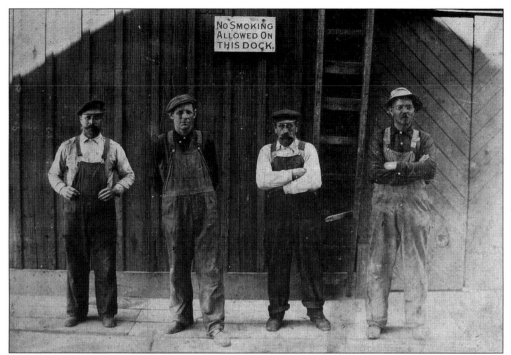

Pictured are workers on the *Chief Wawatam* dock in St. Ignace. The man on the far left is Gus Holm; the others are unidentified. The dock was vibrant with commercial railcars and passengers crossing the Straits of Mackinac, going to and from the Lower Peninsula. In 1986, the rails leading from St. Ignace to the rest of the Upper Peninsula were abandoned. (Hilda Ryerse.)

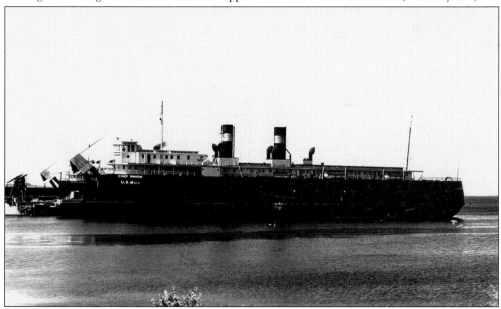

Commodore Lewis Boynton went with a crew to Detroit in 1911 to pick up *Chief Wawatam*. She was the most powerful ice crusher on the straits at the time and had a capacity of 20 railroad cars. When *Chief Wawatam* arrived, *St. Ignace* and *Sainte Marie I* were sold. *Chief Wawatam* gave reliable service until 1984 when rail service across the straits ended. (Donna Bigelow.)

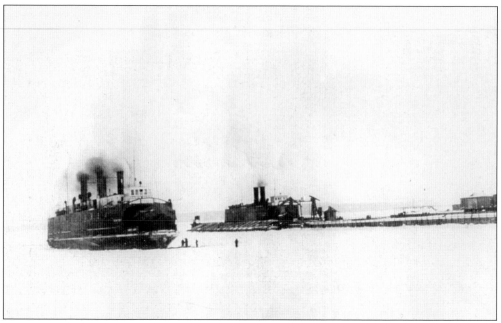

Railroad ferry *St. Ignace* is shown (right) in 1902. *St. Ignace* had sides added to keep the railcars out of the weather. *Sainte Marie I*, built in 1893, is pulled up in the bay (left). In 1911, both *St. Ignace* and *Sainte Marie I* were sold because their wooden hulls were not adequate for the ice in the Straits of Mackinac. (Ollie Boynton.)

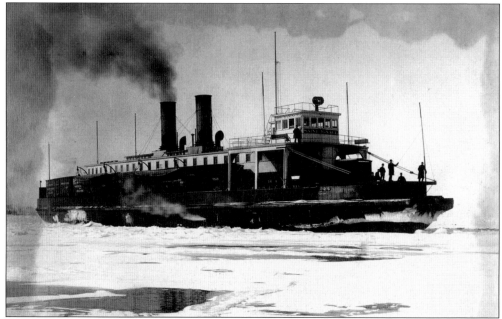

In 1888, Commodore Lewis Boynton and crew went to Detroit to pick up the icebreaker *St. Ignace*. She was the first ice crusher to open the route between the peninsulas on a year-round basis. She had a 10-railcar capacity. One disadvantage was the sides were open and the railroad cars were exposed to the weather. The ship was welcomed to its home port with a celebration. (Mariners Museum.)

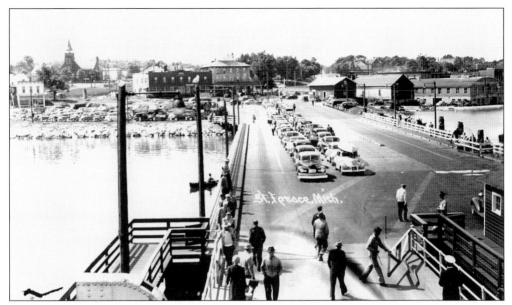

In this 1942 photograph, the coal dock had recently been converted into Michigan State Ferry Dock No. 2. The Quance Building (far left) was used for various businesses over the years. Across from the dock is the Nicolet Hotel (the former Dunham House portion burned in May 1942). At dock-end is the ferry office, later the chamber of commerce. The round-roofed Ray's Motor Sales (far right) is now Ace Hardware. (Phyllis Massey.)

Michigan State Ferry *Saint Ignace* suffered port-side damage when state ferry *City of Cheboygan's* bow crashed into the smaller ferry on a foggy day in June 1939. The 180-foot *Saint Ignace* sustained $10,000 damage from the 20-foot hole above the waterline. Eight people plus the cook were injured, while automobiles on the lower deck were damaged from collapsed upper-deck beams. (Ralph Dolsen.)

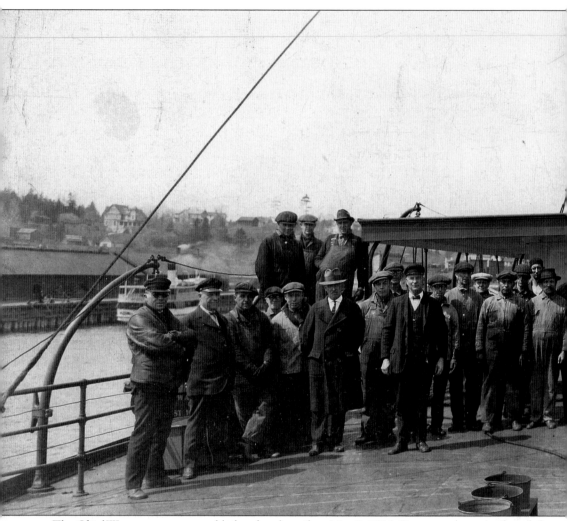

The *Chief Wawatam* crew assembled on her fantail on May 8, 1926. Crew members are, from left to right, (first row) Charles Brown, Joe Taylor, Levi Furlotte, Charles Leveille, Capt. Fred Ryerse, Amos Leveille, Allen Bordeaux, Alexander Tromblay, Frank McGoon, William Graham, August Holm, Charles Carlson, Myron Drier, George Densmore, Charles Closs, John Goulding, Joe Merchant, Katie Hicks, Herb Matson, Benjamin Merchant, John Thibault, Charles Love, and George Taylor; (second row) Charles Gamble, Gunner Nordstrom, Standley Bauers, Jim Tamlyn,

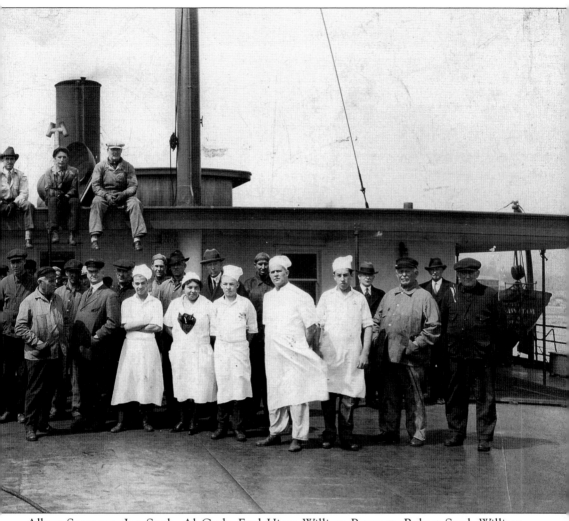

Albert Sorenson, Joe Sterk, Al Groh, Fred Hiser, William Peterson, Robert Steel, William Lowery, Roddy Campbell, John Steel, Alfred Thibault, Leo Fogelsonger, Harry Cheeseman, Frank Rapin, Harry Wood, Charles Gooding (visitor), Henry Durfee, John Hanson (visitor), and James Keightley (visitor); (third row, seated) Don Densmore, George Morrison, and Albert LaJoice; (behind John Goulding) Eric Matson. (Jerome LaJoice.)

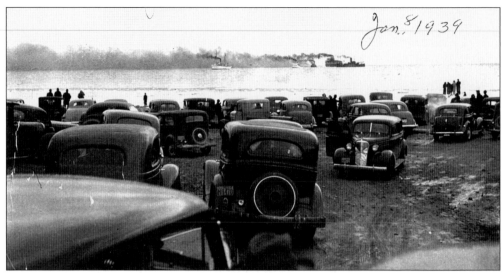

On January 8, 1939, a ferocious blizzard blew *Chief Wawatam* aground on the North Graham Shoals. The boat was lost and unreported for seven hours in the blinding northeast blizzard. Aboard were 33 men and a full load of 22 railroad cars. *Sainte Marie II*, tugboats *John Roen* and *Favorite*, and Coast Guard cutters *Ossipee* and *Escanaba* were all used in the removal of *Chief Wawatam* from the shoal. *Chief Wawatam* ran short of coal and supplies. Steam barge *M. H. Stuart* brought 100 tons of coal and passed the coal through the portholes below the loaded car decks. During the six-day salvage operation an estimated 1,000 persons and 300 automobiles jammed Graham's Point and other vantage points to watch the activities. (Above, Edwyna Nordstrom; below, David Walker.)

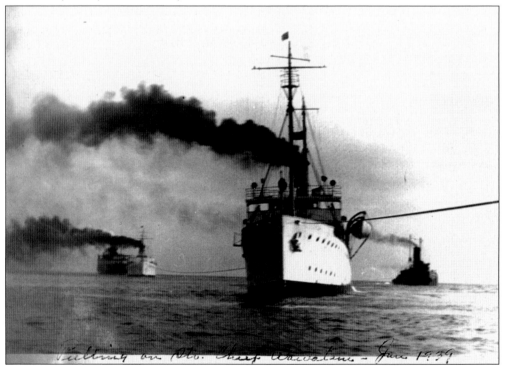

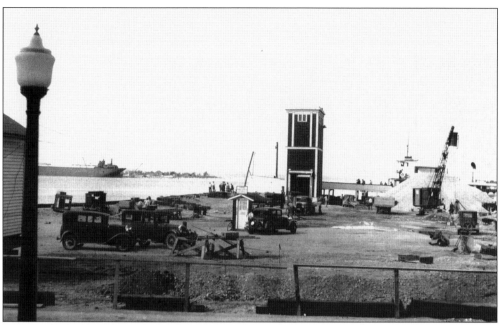

In 1923, the State of Michigan purchased the Chambers dock (directly across from the Chambers home, now Colonial House) for $10,000. It was the only privately owned dock large enough (105 by 205 feet) and with deep enough water to accommodate the state ferries. The dock received some alterations: more sturdy pilings, a reinforced plank surface for cars and trucks, a storage place for the coal supply, and the old warehouse was remodeled for restrooms and a passenger waiting area. Contracts were let that summer to widen the dock roadway for more slips on the north side. The photograph above shows the second update (1932), which included a new concrete deck surrounding the 1931 two-story loading structure. The attractive landscaping (below) demonstrates the interest that the ferry company administration had in the traveling public. (Above, Rae Tamlyn; below, Phyllis Massey.)

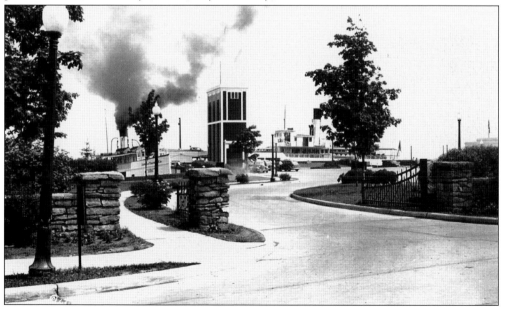

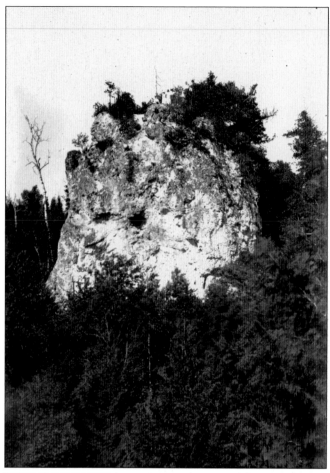

Norton and Lund purchased Castle Rock, a sea stack, in 1927. They built a stairway to the top, opened a souvenir stand, and added tourist cabins. Clarence Charles Eby (1890–1961) bought the 80-acre site three years later. Over time, the gift shop was replaced and expanded. Eby's photographic skills gave birth to a high-volume postcard business. In 1958, Eby's son-in-law, Calvin Tamlyn, handcrafted Paul Bunyan and Babe the Blue Ox at the foot of the stairs. Eby's savvy promotions made Castle Rock into a successful tourist attraction, and it remains in his family still. He published several tourist guides for the area in the 1920s. Not only did Eby promote Castle Rock and his other local businesses, he heartily encouraged other merchants to do the same for their enterprises and for the area. (Mark Eby.)

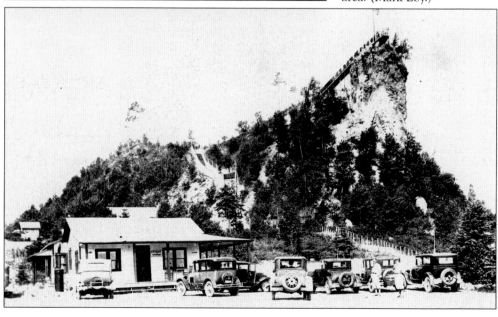

The picture at right shows Phil Case, the Michigan State Ferry office manager. Next to him is Capt. Hilliard Bentgen, superintendent of the state ferries. Stewart Newton (third from left) was in charge of accounting. Lucille Frantz (far right) and Ginevra Walker (seated) did the secretarial work. This photograph was taken in the late 1940s inside the ferry business office at Michigan State Ferry Dock No. 1, where it remained until ferry service ended with the opening of the Mackinac Bridge in 1957. This ferry dock now serves as the location of the Arnold main dock for Mackinac Island ferry service. The Michigan State Ferry crew members (below) are spiffy in their official uniforms. (Above, David Walker; below, Ollie Boynton.)

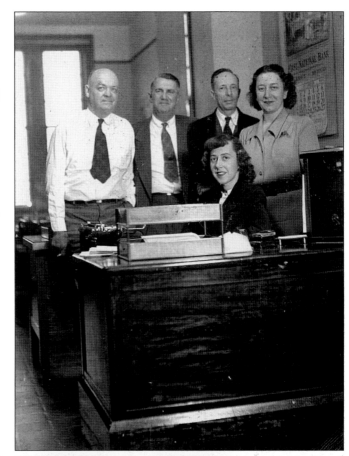

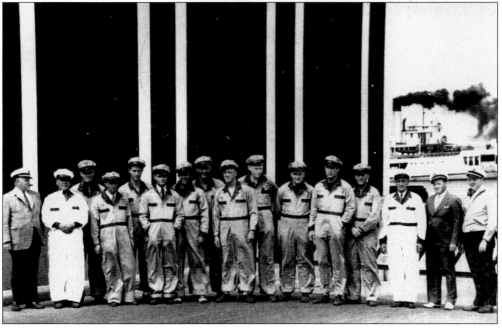

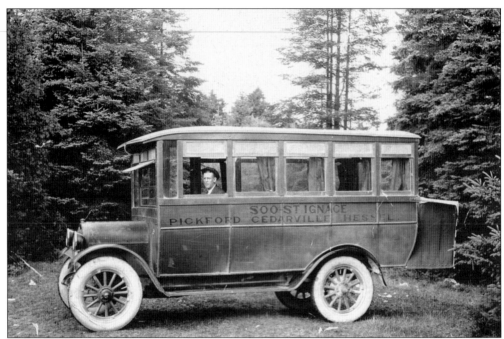

The Yellow Bus took passengers to the Les Cheneaux area, Pickford, and on to the Soo. In the early 1930s, the McGregor brothers also offered service to Manistique. Pictured above, about 1922, is Seth McGregor at the wheel. This sturdy bus even had curtains! A newer (1926 license plate) steel-wheeled version with a luggage rack and split windshield is shown below. Brother Duncan became a captain with Arnold Line and the state ferries. Seth and Adam continued with bus service until Northland Greyhound bought them out in 1944. Greyhound built a modern terminal at 448 North State Street. In 1930, Robert Wynn began a bus line from the Soo to Detroit, with tickets available at Traveler's Hotel. Earlier, Charles Leveille ran a bus to Castle Rock, with special trips to other nearby attractions, including Brevort Lake. (Ernie Krause.)

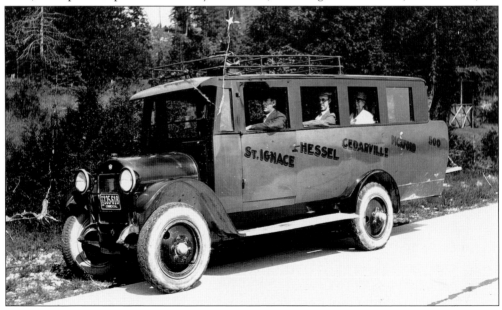

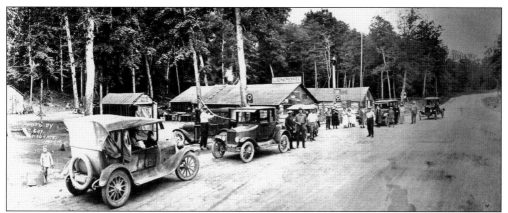

Frank and Opha Miller's restaurant, gas station, and rental cabins flourished through the early 1900s. Located on the only road to Trout Lake, vehicles were routed right by Miller's Camp (above) on the Cut River. After the deaths of the older Millers (1939), their daughter Ida, granddaughter Bertine, and her husband, Milford Fenner, ran the business. In 1942, fire destroyed all but the main lodge and the small gas station. In 1947, when U.S. Route 2 was rerouted for the Cut River Bridge, traffic bypassed Miller's. The business was rebuilt two miles west of St. Ignace. The new Miller's Camp (below), featuring a bar and restaurant, stayed in the family until 1971. Sold first to Paul and Peggy Binger, then Tom and Gelina Weldy, the business is now Timmy Lee's Pub. (Above, Superior View; below, Darlene Fenner.)

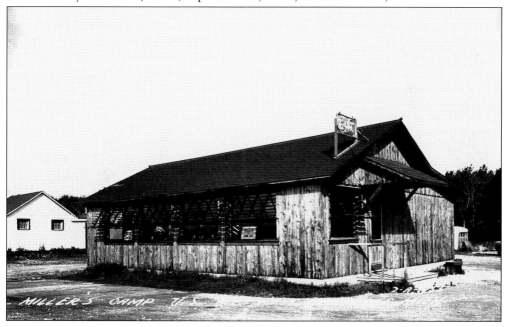

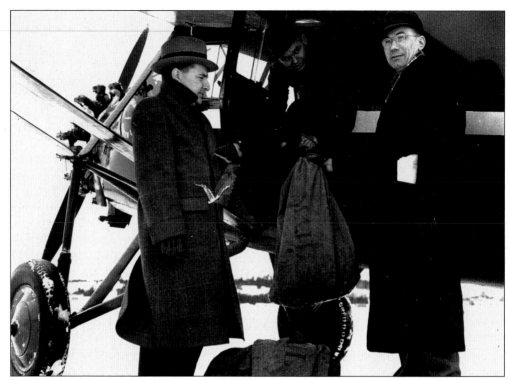

The Mackinac County Airport was named Wing Field for Chester Bert Wing (1888–1964), an aviation enthusiast and owner of a local automobile garage from 1910 to 1956. Below, United States Army planes from Fort Brady at Sault Ste. Marie are being tested with new skis made by Wing's Garage. The airport was created in the area near the former poor farm on land once used by Wing's father to grow strawberries. Chester Wing and his father, Walter, both served terms as mayor. The Wing family sold the airport to the county about 1932, and the terminal was built in 1934. Above, St. Ignace postmaster Oliver Boynton Jr. (right) and an unidentified man assist pilot Bud Hammond (center) in loading mail bound for Mackinac Island on a winter trip, around 1939–1940. (Above, Ollie Boynton; below, Paul Fullerton.)

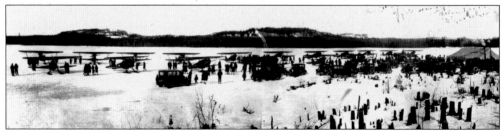

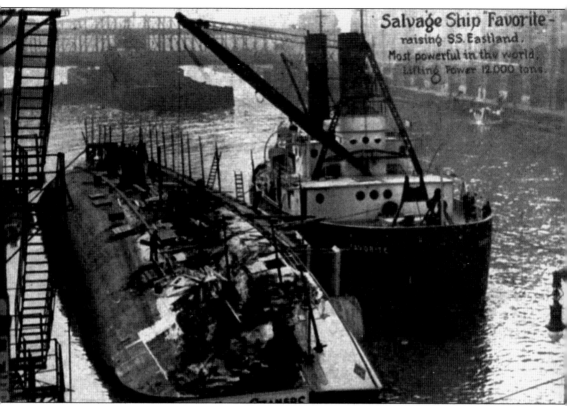

Salvage Ship "Favorite" – raising SS. Eastland. Most powerful in the world, lifting power 12,000 tons.

Great Lakes Towing purchased the 139-foot wrecking tug *Favorite*, built in 1864 as a steam passenger vessel and converted for salvage work in 1890. Used for the toughest salvage jobs, she was destroyed by fire at Favorite Dock in January 1907. At 195 feet and launched in 1907, the steel-hulled *Favorite* (2) was the largest self-propelled vessel built for salvage and rescue work on the Great Lakes. Shown above, she is salvaging the excursion steamer *Eastland*, which rolled over in the Chicago River with a loss of over 800 lives. *Favorite* was on this wreck for three weeks in 1915. Requisitioned for government work by the United States Shipping Board in 1917, she did duty in Maine, France, and Panama. *Favorite* (3), built in 1919 for Great Lakes Towing, worked until 1954 and was scrapped in 1958. *Favorite*'s dock is now used for freight and horses going to Mackinac Island and for ferry maintenance. (Judy Gross.)

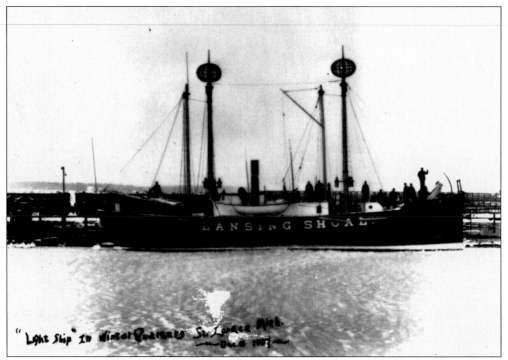

Lightships were used by the U.S. Coast Guard in spots where lighthouses would be inconvenient due to cost or inhospitable sites. This lightship served at Lansing Shoal from 1900 to 1920. She was built in 1891, costing $14,225. She had a cluster of three oil-burning lens lanterns hoisted on each masthead, a fog signal, and a hand-operated bell. The lighthouse was erected in 1928. (Jack Deo/Superior View.)

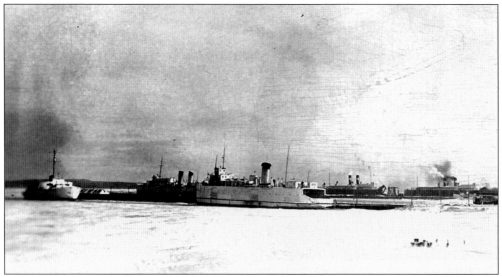

This is an unusual picture taken about 1951. The five boats in the St. Ignace harbor are Coast Guard cutter *Mackinaw*, *City of Munising*, *City of Cheboygan*, *Sainte Marie II*, and *Chief Wawatam*. This picture was taken in late winter, and it looks as if *Mackinaw* was about to break out the state ferries for the start of a new season. (Violet Gustafson.)

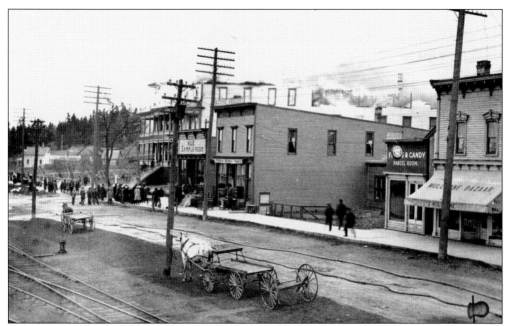

The Cadillac Hotel (originally Sherwood House, built in 1888) stood at the corner of State and High Streets across from the depot. The 200-room hotel was not rebuilt after this 1911 fire. Although a few of the newfangled horseless carriages had been seen in St. Ignace since 1908, horse-drawn conveyances were still the norm. The Cadillac site is now occupied by True Value Hardware. (David Walker.)

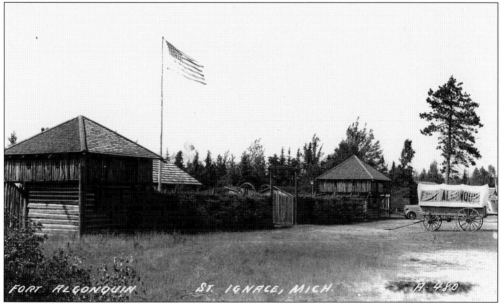

Fort Algonquin was built as a reproduction fort and trading post by Henry Vaughn Norton in 1928 as a tourist destination. He used his collection of Native American artifacts to open the fort. It was not only a commercial venture but also an educational museum. In the 1970s, the collection was sold for display at Fort de Buade. Warren and Kim Hagen, Norton's descendants, operate it today. (Phyllis Massey.)

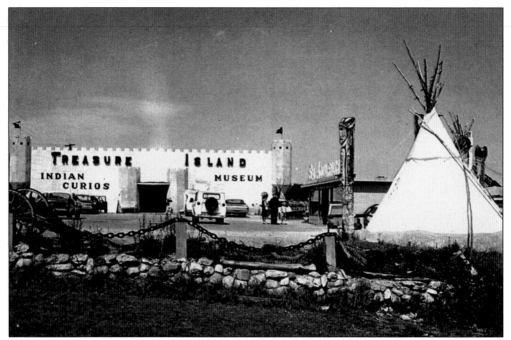

Treasure Island was a museum in the 1960s owned by Jack and Grace Barnhill. The Barnhills started in the souvenir business in the late 1940s, then sold out and established Treasure Island. The building was first used by Irving H. Kolbe for a fish processing plant. It is now the main terminal and office for the Star Line Mackinac Island Ferry. (Pat Andress.)

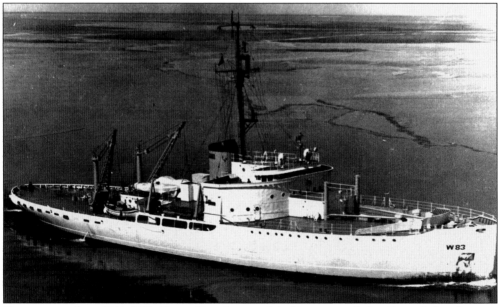

Commissioned in 1944, U.S. Coast Guard cutter *Mackinaw* served the Great Lakes for over six decades. Stationed at Cheboygan, she was often on duty in the Straits of Mackinac. The 290-foot icebreaker is not designed to ram or plow into ice, but rides up on the ice surface and crushes through. She was decommissioned in 2006 and is now a static museum at Mackinaw City. (Jack Deo/Superior View.)

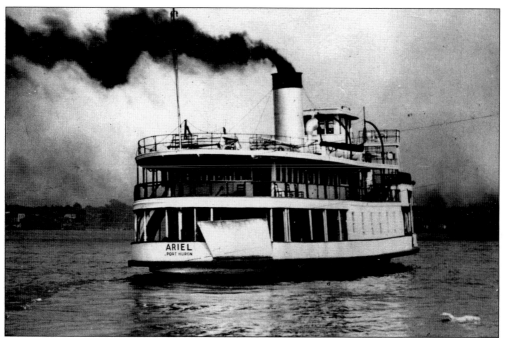

The first Michigan State Ferry was the little wood-hulled *Ariel*. The 41-year-old 110-footer was purchased from Hiram Walker's Detroit-to-Walkerville ferry company for $10,000. Her official start as an automobile ferry on the straits was on August 6, 1923. Able to carry only 20 automobiles, she was so small that she was soon replaced. (Michilimackinac Historical Society.)

John Donnelly and his wife, Jackie, came to St. Ignace in 1937 to open a Mobil station. John had been in the oil business in Sault Ste. Marie. The station was located at State and Truckey Streets. John served in the army during World War II. Upon returning, he went into the oil business again across from the Traveler's Hotel. John was mayor of St. Ignace from 1954 to 1956. (Paul Donnelly.)

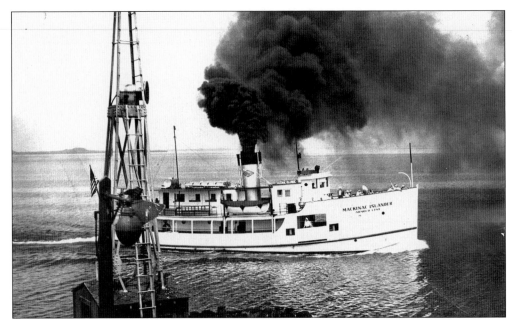

The ferry business has evolved through the years, with several company names and changing partnerships, which included James Keightley, Joseph Fitzpatrick, Lewis Boynton, and George Arnold at different times. As roads were developed and improved, the coastal ferries were not needed and Arnold Transit concentrated on the Mackinac Island routes. Ice crusher *Algomah* became an island ferry after her railroad service. Above is *Mackinac Islander*, passing *Chief Wawatam*'s dock, on her way to the island. On Sundays in the summer of 1895, one could enjoy a round trip to Mackinac Island, with a band aboard, for the special rate of 25¢. Four diesel ferries built between 1955 and 1962, *Huron* (below), *Ottawa*, *Algomah*, and *Chippewa*, have handled the transporting of freight, horses, mail, and passengers to Mackinac Island for decades. (Above, Donna Bigelow; below, Bobby Brown.)

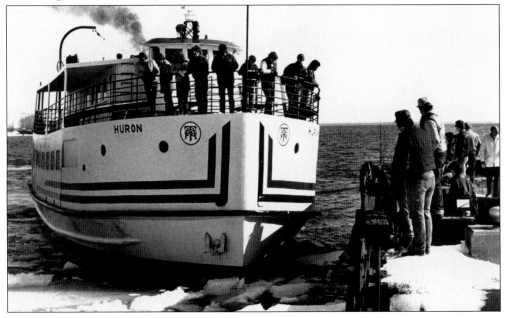

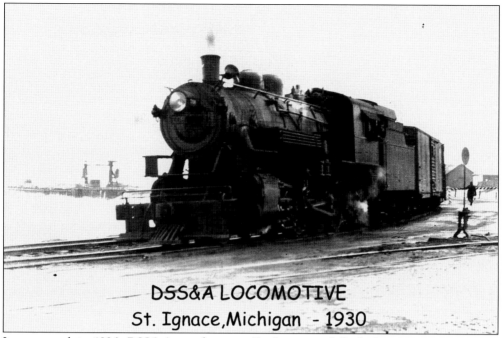

DSS&A LOCOMOTIVE
St. Ignace, Michigan - 1930

Incorporated in 1886, DSS&A ran between St. Ignace and Sault Ste. Marie to Superior, Wisconsin, and Duluth, Minnesota. Other branches soon crisscrossed the Upper Peninsula, providing passenger and freight service. Freight operations discontinued mid-century, but passenger service was available through 1957. In 1961, DSS&A ceased operating independently and became part of the Canadian "Soo" Line Railroad. DSS&A and Soo Line trains crossed State Street twice each day with a morning and evening scheduled train. There was much switching of freight cars at all hours and traffic backups on State Street. The sound of train bells ringing and cars being bumped together during the switching operations could be heard for blocks. (Ollie Boynton.)

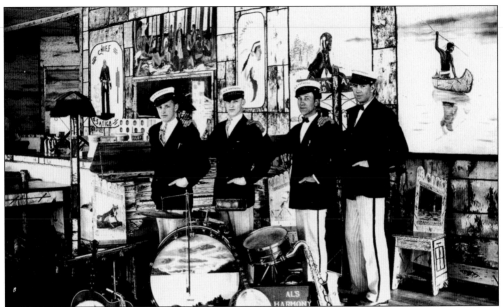

Opened in 1926, Birchwood Arbor, located on State Street just south of Michigan State Ferry Dock No. 1, included a restaurant, dance hall, and gift shop. The whole interior (above) was decorated with real birch bark, murals, and hand-painted furniture done by Orr Greenlees. Ellsworth "Frenchie" Vallier, owner and operator, hosted club parties, luncheons, school dances, and in summer daily concerts and orchestra dances nightly. Many bands performed there over the years, and above are Al Roggenbuck's Harmony Kings. The front and 65 feet of the ferry dock side were all glass. Vallier had his automobile (below) painted to look like birch bark, advertising his business. By 1931, Clarence Eby had purchased the Birchwood for $4,000, redesigning it into a curio store. The Birchwood was razed in the late 1930s and is now an Arnold parking lot. (Rae Tamlyn.)

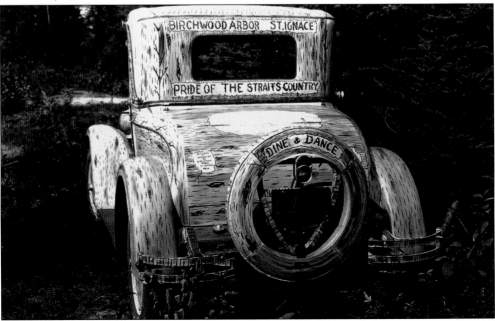

Four

THE TOWN
AND TOWNSPEOPLE

Dr. James Floyd Darby came to St. Ignace in 1896, where he married Molly McCann. During his 52 years in practice, he delivered over 5,000 babies. Pictured beside him are grandsons Walter and James Droskie, Carol Lou Rabideau on Darby's lap, Rita Robinson, Sally Quantz, Jackie and Shirley Thibeault, Jerry Arnold, and three unidentified children at the far right. (Kathy Cronan Feher.)

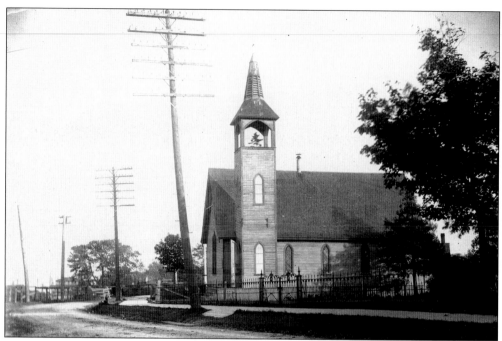

The Episcopal Church of the Good Shepherd was constructed in 1882 at the north end of town. In the winter of 1890, it was moved by a process, repeated many times, requiring digging a hole in the roadbed and anchoring a capstan to a buried deadman. Then horse-drawn teams skidded the building over the icy roads to its present Prospect Street location. This photograph is from around 1900. (Margaret Peacock.)

Keightley Street is named after James and Emma (Benchley) Keightley. James came to the United States, at age 19, in 1872. He went from freight clerk on the railroad to purser on *Algomah* and ice crusher *St. Ignace*, and later a co-owner of the Island Transportation Company. Both James and Emma were active in the community and their church. (Margaret Peacock.)

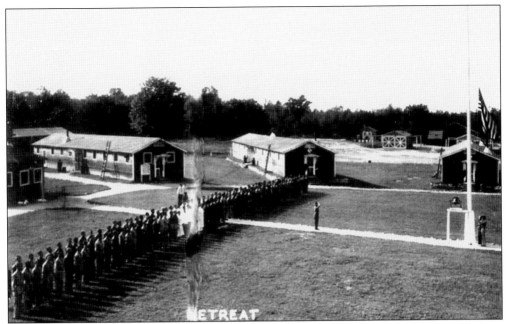

Civilian Conservation Corps Camp Round Lake was founded in 1935 just off U.S. Route 2 about 12 miles west of St. Ignace. For $30 a month, the young men built roads, planted trees, fought fires, cleared logging debris, and aided in the construction of the St. Ignace City Hall in 1939–1940. At Brevort Lake Campground, they constructed a dam, bathhouse, log shelters, toilets, wells, tables, and fireplaces. (Civilian Conservation Corps Museum, St. Louis, Missouri.)

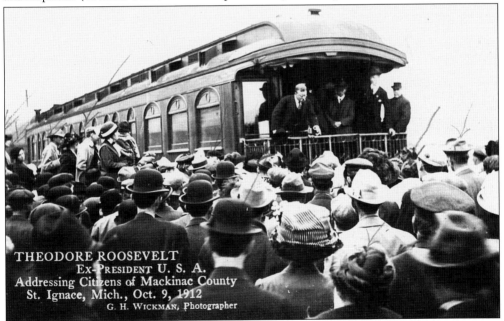

St. Ignace was visited by former president Theodore Roosevelt, on his campaign train on October 9, 1912. Having served as the 26th president from 1901 to 1909, Roosevelt ran for election again under his own party, the Progressive Party, or as he called it, the Bull Moose Party. He was defeated by Woodrow Wilson. (Edwyna Nordstrom.)

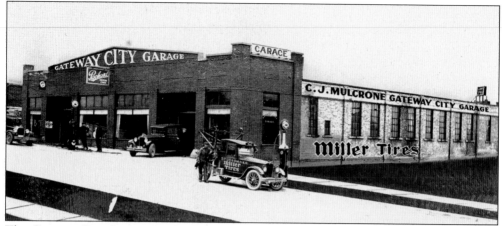

The Gateway City Garage was located in this substantial brick building on McCann Street near State Street. The proprietor, Charles Mulcrone, offered Packard, Studebaker, Hupmobile, Hudson-Essex, Pontiac, and Oakland automobiles for sale. He could also provide automobile repairs, fire-proof storage of automobiles, and wrecker service—just phone him at No. 57! Mulcrone played football at Notre Dame and was St. Ignace's mayor from 1930 to 1932. (Mike Lilliquist.)

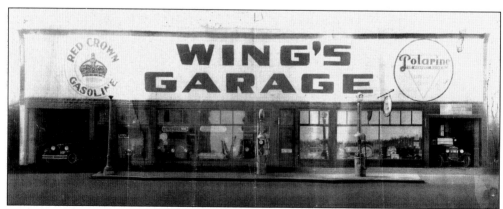

Wing's was the first garage in St. Ignace dedicated to selling and repairing automobiles. It was established by Chester Wing in 1910 and remained in business until 1956. Since the first horseless carriage arrived in town about 1908, Wing's Garage was servicing the first of the automobiles to be used by St. Ignace residents. Later the garage was used to develop the motorized iceboat. (Ashcan Furlott.)

The St. Ignatius Loyola parish church was enlarged and reconstructed, and a basement was added in 1948–1949. St. Ignatius was built in 1904, but a fire in 1942 forced the parishioners to return to their first parish church, the old Mission Church. That church, dedicated in 1837, now serves as the Museum of Ojibwa Culture and is adjacent to the site of the historic grave of Fr. Jacques Marquette. (Don Gustafson.)

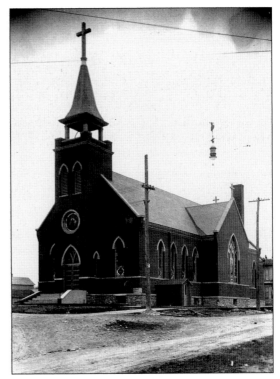

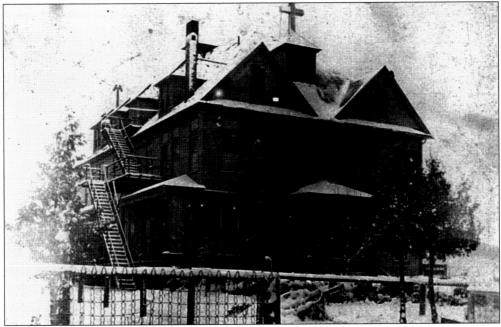

The Ursuline Academy was established in 1897 by three Ursuline sisters from Chatham, Ontario. With the help of the parishioners from St. Ignatius Loyola, they raised the funds to build the Academy of Our Lady of the Straits. The academy opened on September 8 with 60 students. The Convent, as it became known, originally graduated high school students but was an elementary school when it closed in 1972. (Hilda Ryerse.)

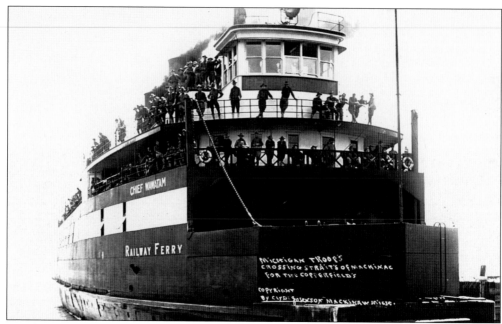

In July 1913, there was a major copper mine strike in Calumet. Fifteen thousand men were out of work. Their demands of the Western Federation of Miners Union were for an eight-hour day, abolition of the one-man drill, and better working conditions. Gov. Woodbridge Ferris dispatched the Michigan National Guard to Calumet to keep order. Pictured above are the troops aboard *Chief Wawatam* approaching the railroad dock in St. Ignace. The picture below shows the troops' encampment. The location is the large area at the east end of South High Street, the present site of the True Value Hardware and the United States post office. (Above, Tom Pfeiffelmann; below, Ollie Boynton.)

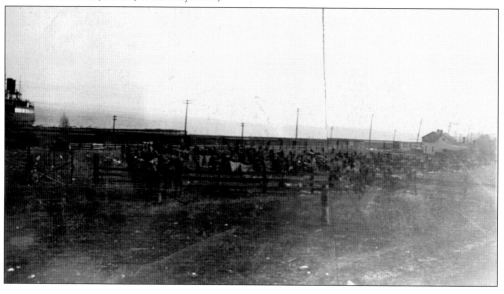

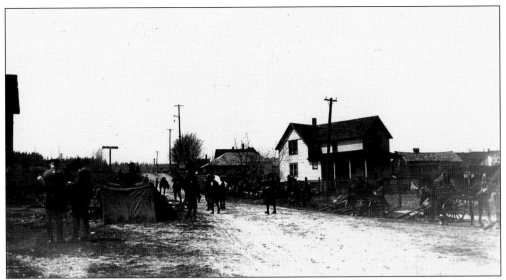

Both of these pictures are in connection with the Calumet copper mine strike in 1913. The Michigan National Guard is on its way to Calumet, stopping over at St. Ignace. The tents, soldiers, and equipment are on South State Street in the above picture. The large house on the right is still there and owned by Ron Dufina. The lower picture was taken in the field across from the railroad dock. The Michigan National Guard has a lot of equipment. Note the mule on the far left. The carts with the large wheels most likely were used to haul tents and other supplies. (Ollie Boynton.)

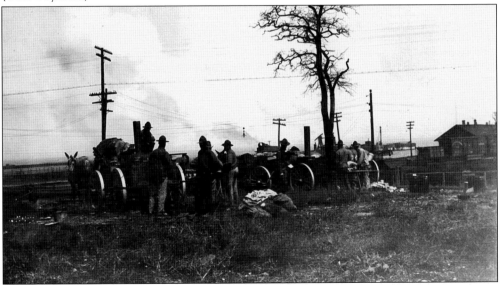

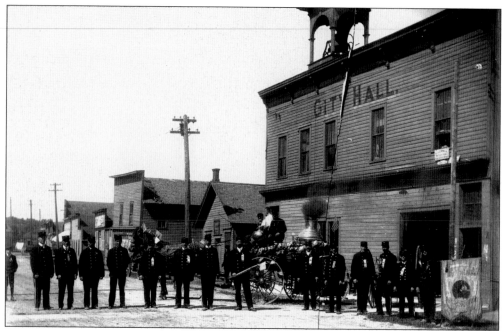

Early-1900s firefighters are, from left to right, William Curtin, John Vallier, P. Grondin, Frank Vallier, Frank Mosher, Henry Lake, Jackie Moore (chief), Al Newman, Tom Johnston, Jack Dill, Sam McLean, Paul Smith, Ben Vallier, S. A. Russell, (on steamer) Joe Quinn, Murray Quinn, and Scotty Miles. At first, volunteer firefighters pulled the hose carts. Later horse-drawn steam pumpers were used until city hydrants were available. (City of St. Ignace.)

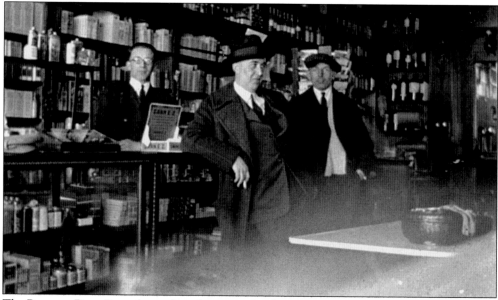

The Boynton Drug Store, located on the west side of State Street near Truckey Street, operated in the 1920s. It was a well-stocked drugstore and also had a soda fountain with ice cream, tables, and booths. Behind the counter is Oliver C. Boynton Jr., the pharmacist. Leaning on the counter is Albert McCuen, proprietor of the barbershop adjoining the drugstore. The third man is unidentified. (Ollie Boynton.)

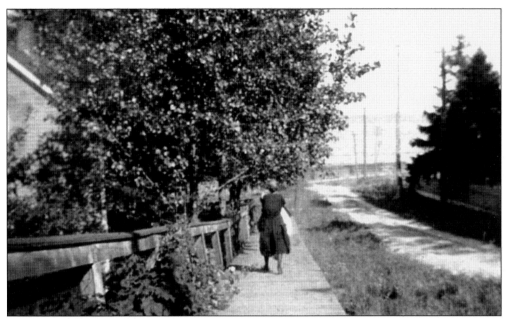

An unidentified woman heads down Fitch Street toward the lake. This steep street was named for the Ernest and Emily (Wray) Fitch family, who lived atop the hill until 1908. Their son, Aubrey Wray Fitch (1883–1978), became a pilot, head of the United States Naval Academy (Annapolis), United States Navy rear admiral, and commander of one of the first World War II task forces in the Pacific. (Hilda Ryerse.)

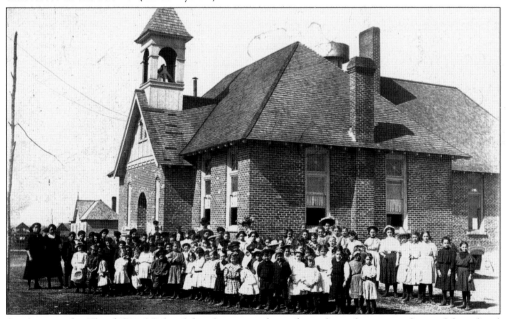

Students at the Third Ward School, kindergarten through sixth grade, pose in front of the school in the early 1900s. The school was on the corner of St. Antoine and North State Streets. The school closed in the mid-1900s. The First Ward School was on Bertrand Street at the current site of the Faith Baptist Church. Students in the Second and Fourth Wards attended the McCann Street School. St. Ignace was divided into four wards for voting purposes. (Florence Sturt.)

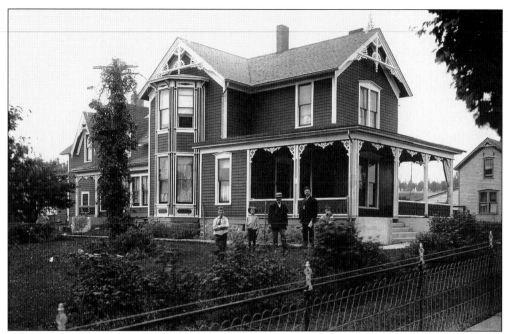

Capt. Lewis R. Boynton built this home on McCann Street in the late 1800s. Standing in the yard are, from left to right, James W. Boynton (Lewis's grandson), unidentified, Lewis, unidentified, and Oliver C. Boynton Jr. (also a grandson) holding the dog. This house is currently serving as Dodson Funeral Home. (Ollie Boynton.)

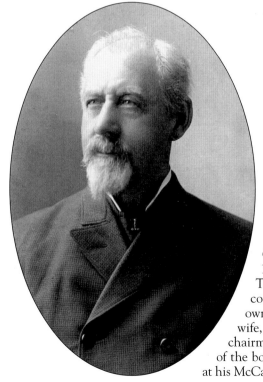

Capt. Lewis R. Boynton came to St. Ignace in 1884 and became commodore of the Mackinac Transportation Company. He managed construction and repair and was managing owner of the steamer *Algomah*. Boynton and his wife, Sarah (Kendall), had 11 children. He was chairman of the board of public works and president of the board of education. He retired in 1913 and died at his McCann Street home in 1926. (Ollie Boynton.)

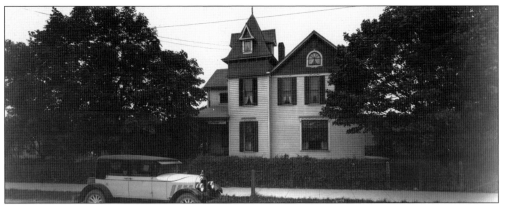

This McCann Street home was built by John Mulcrone after he came to St. Ignace in the early 1880s. John and his brother, Michael, went first to Mackinac Island when they arrived from Ireland in 1863. Both brothers were active in civic affairs. John was mayor from 1896 to 1897. John's daughter, Helen, ran a rooming house here, across from the funeral home. (Mike Lilliquist.)

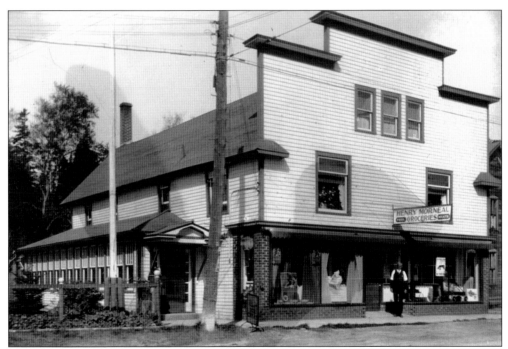

Henry Morneau opened his grocery store in the Third Ward about 1910. Manley's Smoked Fish is now on this site, which is still owned by the Morneau family. For years this area of State Street was known as Morneau's Corner. After the store burned in 1960, the chimney remained for many years. (St. Ignace Public Library.)

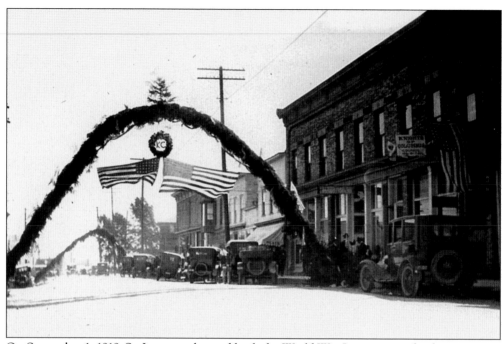

On September 1, 1919, St. Ignace welcomed back the World War I veterans with a homecoming parade and community dinner. The parade started at the courthouse and passed under several evergreen arches on its way to the depot. Folks flocked into town, filling accommodations and overflowing into private homes. This arch, sponsored by the Knights of Columbus, was joined by others erected by the local Moose Lodge. (Edwyna Nordstrom.)

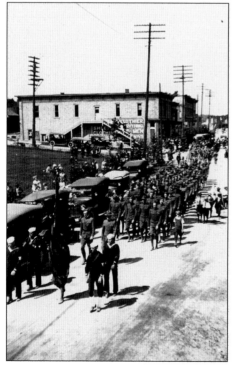

Mackinac County sent 387 men to the World War I effort. The Avery family had five brothers who enlisted. One of them, Arthur, was the first from this area to reach France, and he was seriously wounded in battle. Four Bourisaw boys served in the army. Twenty-two Mackinac County men lost their lives in service to the country during World War I. (Michilimackinac Historical Society.)

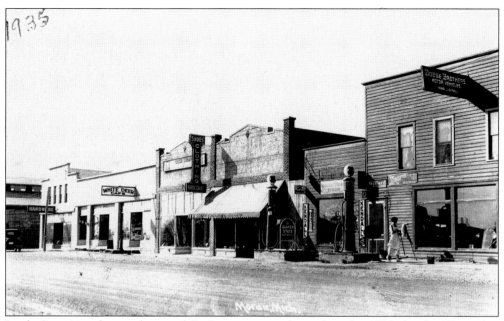

Jacob City, 11 miles northwest of St. Ignace, was colonized in the 1880s by the 27-member German Land Company. It was an agricultural settlement with farms located outside the village limits and lots in town. In 1883, the organization borrowed money from William Moran to buy more land and the town's name was changed to Moran. The town remained small, as seen in 1935. (John Lipnitz.)

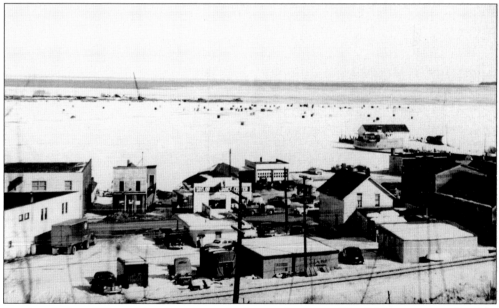

Dotting the ice of Moran Bay, shanties made the popular sport of ice fishing more comfortable. Sport fishing brought visitors, and there has always been a fishing industry in the area. Looking across the railroad tracks, one of the island ferries is in storage at Favorite Dock. A crane awaits warmer weather out on the old mill slip, now used for boat storage in the winter. (Michilimackinac Historical Society.)

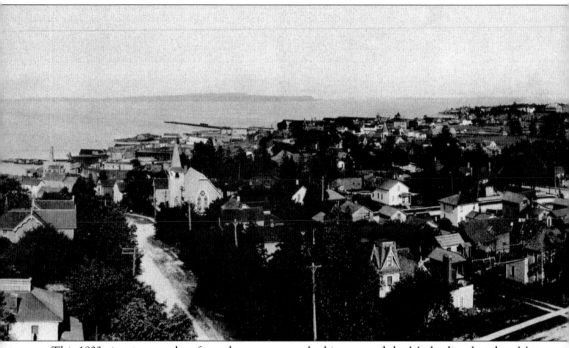

This 1922 picture was taken from the water tower looking toward the Methodist church at Mary and Goudreau Streets. Previously the Sunday school had met in a small house owned by the Mackinaw Lumber Company. In February 1881, a 20-by-40-foot church was built on a lot just northwest of St. Anthony's Rock—in one day! It was so small that the church in this picture was built that same year and was ready to use for Christmas Eve. The present Methodist church, across from St. Ignace Public Library, was built in 1959. Mackinac and Round Islands are visible on the horizon. LaSalle School can be seen at the top center with its bell tower and the Convent at upper far right. Goudreau Street runs right down to State Street, the municipal building and fire department are on that corner today. In this picture, however, the city hall/fire department is the building at the far left, on the lake, with the fire bell tower at front of its roof and the fire siren at rear. (Dottie Glashaw.)

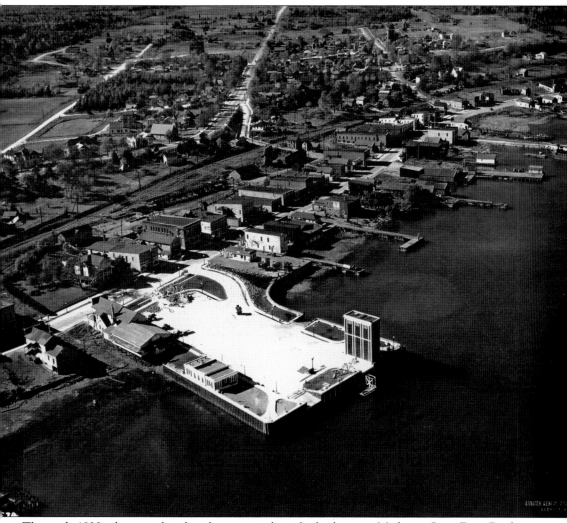

This early-1930s photograph, taken from an airplane, looks down on Michigan State Ferry Dock No. 1. On the south side of that dock is Birchwood Arbor. The house right next door to the south was moved across the street and became Bentley's Restaurant. Next north of the ferry dock is Rube Carlson's taxi stand and then the Quay Building. Both offered gasoline for sale from pumps out front. The railroad right-of-way, now Chambers Alley, runs behind the Chambers home and past St. Anthony's Rock. Above the railroad tracks at the far left there is laundry hanging out on a clothesline! At the top of the picture is the water tower, directly north of the courthouse. Straight below the courthouse on the curve of Prospect Street is the Episcopal church. To the left of the church is Orchard Lodge Tourist Home at the corner of Prospect and Truckey Streets. The fifth pier north of the state ferry dock is Favorite Dock. (Abrams Aerial Survey Company.)

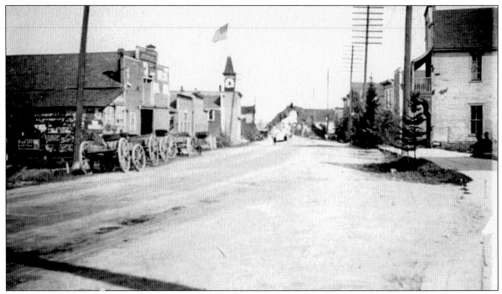

Looking south on State Street (from present Goudreau Street), about 1906, at right is Snyder House and Snyder's Livery at left. The firehouse and city hall bell tower are midway on the lake side. Wooden sidewalks were built along State Street in 1883, and soon after, the city council enacted a five-mile-per-hour speed limit. In 1925, State Street was paved and the utility poles were moved into the alley. (David Walker.)

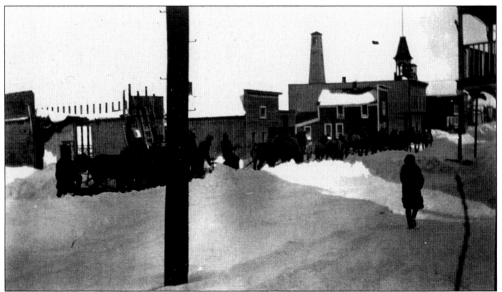

State Street was cleared by horse-drawn plows up into the 1920s. Drivers walking behind the teams and guiding the wooden plows made a wide path in the snow. The fire station/city hall is on the lake side with the bell tower at the front and the fire siren at the rear of the roof. Present-day city hall is located near the porch at right, which was the Snyder House. (Velma June Gustafson.)

Worship had taken place in private homes for years, and the first Lutheran church was originally a flat-roofed building purchased in 1905 from the Martel Furnace Company for $100. It was moved to a site just south of the present-day church. As the congregation grew, the building was enhanced as seen above. It was torn down in 1959 after the new church was built. Below is the first confirmation class of Zion Evangelical Lutheran Church on March 31, 1907, one day after the church was formally established. The confirmation class members are, from left to right, Ivar Fuser, Gerda Nelson Sayles, Julia Gustafson Lovedahl, Lena Sorenson, Jennie Sorenson Peterson, and Lizzie Johnson Nelson, with Reverend K. J. Peel seated. (Pastor Tari Stage-Harvey.)

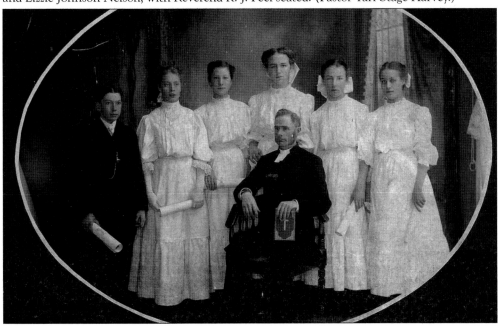

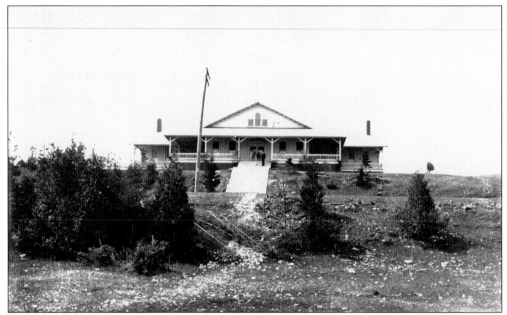

The Pavilion, built by the city in the early 1890s, burned down in 1932. It was originally intended for the use of hay fever sufferers and later, dances were held there. It fell into disrepair and was being restored at the time of the fire. The early-morning fire rapidly destroyed the building. It may have been started by a carelessly discarded cigarette. (Wesley Maurer.)

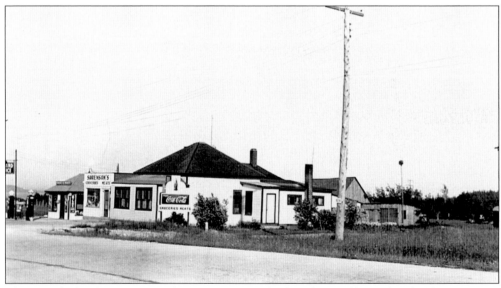

This Standard Oil gas station and grocery store was built and owned by Neil and Lydia Sorenson. This 1940 picture shows the station and store on U.S. Route 2, just west of the current Northern Lights Restaurant. Note the barn and chicken coop and the glass crowns on the two pumps (far left). Neil's son, Stan, built a larger gas station in 1947, when he came home from World War II. (Bob Belonga.)

Genevieve Goudreau (1865–1958) came to St. Ignace in 1886 with her husband, Louis, and became known as Aunt Jane to everyone. As a teenager, she washed dishes in a lumber camp for 50¢ a week. Louis worked on the ferries for decades, and Aunt Jane cooked aboard the boats. An avid collector, she is shown in 1948 with a sap bucket and neck yoke she used as a child. (Michilimackinac Historical Society.)

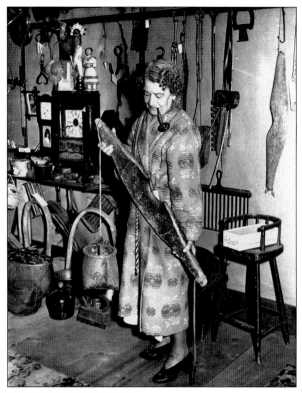

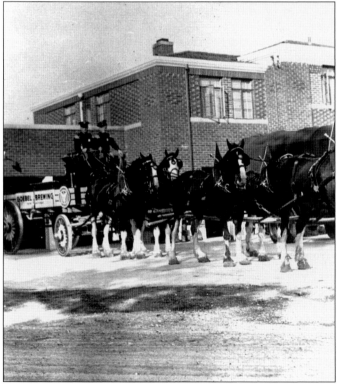

These Clydesdale horses, sponsored by the Goebel Brewing Company, are getting ready for the Fourth of July parade in 1939. Elvin T. Smith, Terry Smith's father, was in charge of the Goebel Clydesdales for many years. He traveled to 45 states with the teams. The hitch is just leaving the state police post on North State Street. (City of St. Ignace.)

99

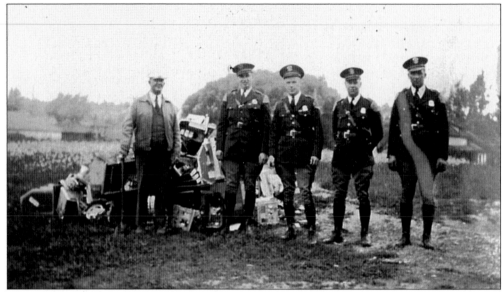

The Michigan State Police and the Mackinac County Sheriff's Department confiscated 20 slot machines during a raid at an illegal gambling location on Mackinac Island in July 1935. Below, an unidentified man with an axe and two state troopers pose with the machines, which were destroyed at the county courthouse in St. Ignace. Raids on illegal gambling were also conducted in Clark Township and at Brevort Lake. After being broken open, about $400 was recovered from the slot machines confiscated on Mackinac Island. Some of the money covered county expenses for the raid, and the rest was taken by the state. (Edwyna Nordstrom.)

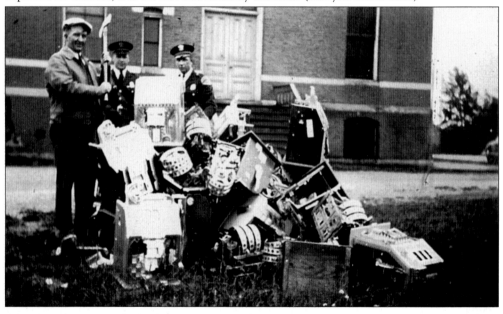

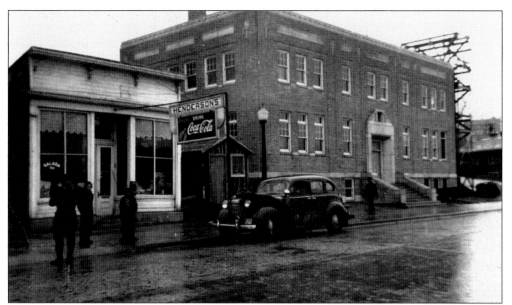

The St. Ignace City Hall was built in 1939 by the Works Progress Administration. The scaffolding on the north side indicates the building is just being finished. This building has served the city well for 69 years. The small building to the south of the city hall was a candy, tobacco, newspaper, and grocery store operated by George and Grace Henderson for many years. (Bruce Dodson.)

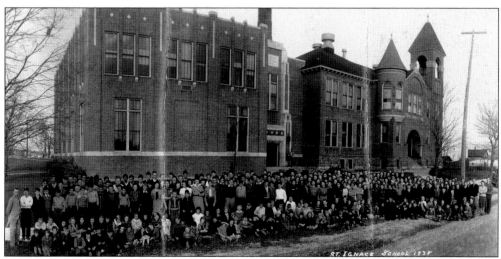

The entire 1938 student body poses in front of the LaSalle High School building on the corner of Spring and Chambers Streets. Only the middle and left sections of the building exist today. The class of 1962 was the last senior class to graduate there. The new school on Portage Street opened in the fall of 1962. (Bob Nelson.)

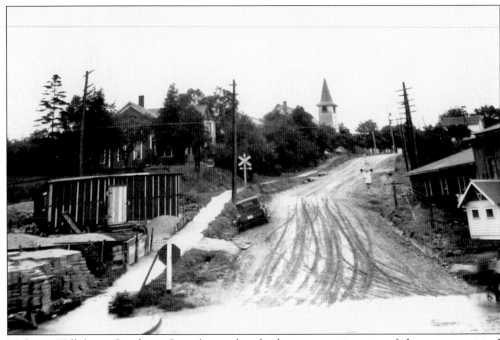

Moloney Hill (now Goudreau Street) runs beside the construction site of the new municipal building, a 1939 Works Progress Administration project. The steeple of the (1881) Methodist church is visible at the corner of Mary Street. The railroad right-of-way is now Chambers Alley. Four buildings—a hotel, a residence, and two stores—had been razed to make room for the new city hall. Looking down Moloney Hill (below), the wooden scaffolding is in place to begin construction. Steam shovels are working across State Street on the Favorite Dock. The stairs at right go up to the Fair family home and remain in place today. Although State Street was paved in 1925, the hill was still dirt—and dusty! (Ralph Dolsen.)

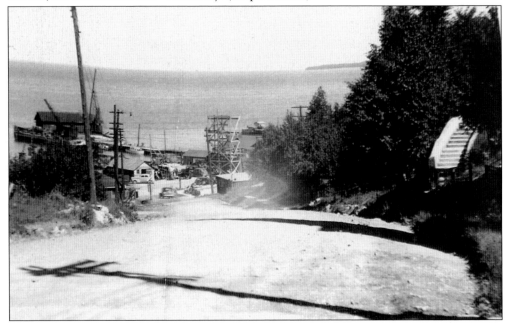

This street scene shows downtown St. Ignace in the 1940s. The population in the 1940s was around 2,500, similar to today's population. The St. Ignace Fish Company operated from the late 1920s into the 1940s. As fishing and lumbering waned, tourism became more important to the St. Ignace economy. (Ollie Boynton.)

Bentley's Restaurant has been popular with locals and tourists since 1937. The building was a residence located across State Street until it was moved to its present site in the late 1930s. It was owned by the Bentley family until a few years ago. The new owners renamed it Bentley's B-N-L and changed the decor, but kept the 1940s fixtures. (Madeline Adie.)

Joe Perry Sr. (left) and R. E. Cronan are shown at the building site of the American Legion Hut located on Business Interstate 75, near Bell Street. Cronan was the commander at the time of construction. The post was organized in 1919 and was named for Thomas F. Grant, who was from St. Ignace and died of wounds received in World War I. (Cathy Cronan Feher.)

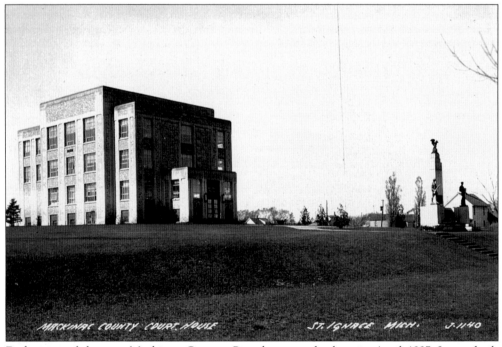

Dedication of the new Mackinac County Courthouse took place in April 1937. It was built with Works Progress Administration assistance on the actual foundation of the old courthouse. Interestingly, the principal speaker was Prentiss M. Brown and the main speaker at the dedication of the 1882 courthouse was his father, James J. Brown. The memorial in front honors the sacrifices of all Mackinac County military veterans. (Michilimackinac Historical Society.)

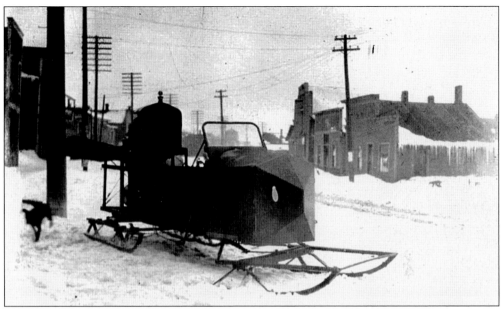

Pictured above is an early version of the motorized sled developed by Chester Wing, owner of Wing's Garage. It is parked in front of his garage on North State Street (now Fort de Buade). Prior to the development of the motorized sled, the traditional iceboat was wind powered and used sails. Frequent races were held in the winter on Moran Bay when the thick ice developed. Below, Jilly Hagen and son, Charlie, are in a later model motor sled in the 1940s. Over the years, Wing improved the contrivance and met with considerable success. (Above, Edwyna Nordstrom; below, Sue Huffman.)

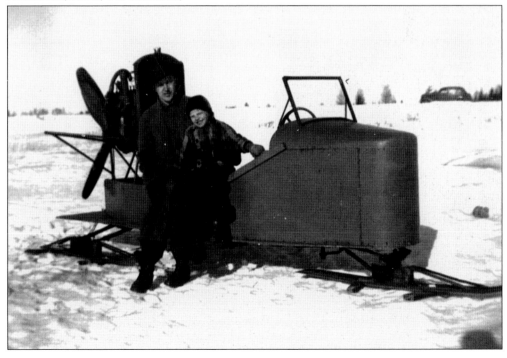

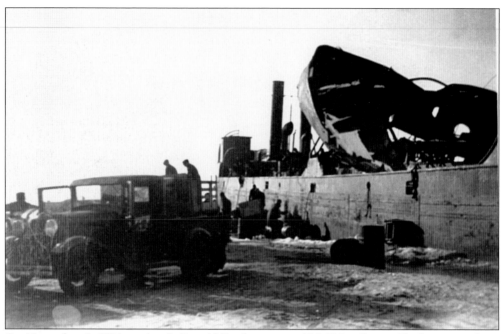

On November 8, 1936, tanker *J. Oswald Boyd,* carrying 900,000 gallons of high-test gasoline, went aground on Simmons Reef, near Beaver Island. With the crew of 19 men safely removed, the owners abandoned the vessel. The country was just recovering from the Great Depression and a pump price of 20¢ per gallon made the "free" gasoline very tempting. Salvagers using small boats gathered to collect what they could. They did get a few gallons, but in late November, the salvaging stopped as one skipper was burned when his tugboat exploded. Rights of salvage were sold to a Beaver Island company, which dispatched its tug *Rambler* and later mail tug *Marold II,* which could handle 20,000 gallons per trip. (Above, Shirley Bentgen; below, David Walker.)

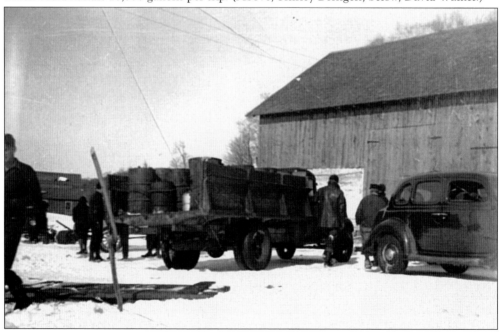

On the first day of 1937, siphoning caused *Marold II* to explode, killing Capt. H. L. Hill and three crew members. The explosion left part of the tug's hull on the *Boyd*'s deck. The Coast Guard began patrols to keep watercraft away. Later an ice bridge formed and salvagers from Sault Ste. Marie, St. Ignace, Cedarville, Newberry, and even Escanaba descended in trucks, horse-drawn sleighs, cars, and tractors. Elmer Lamoreaux, from Clark Township, nearly lost his truck when its rear axle went through the ice. Carl Worth, of Worth's Trading Post, near Brevort, used a sled with special racks to haul 55-gallon drums on his tractor. Vehicles were lost, and at least six people died before the spring thaw ended the salvaging. The *Boyd* was removed from the reef and taken to Sault Ste. Marie. (Above, Shirley Bentgen; below, David Walker.)

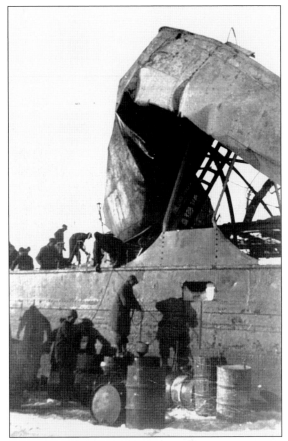

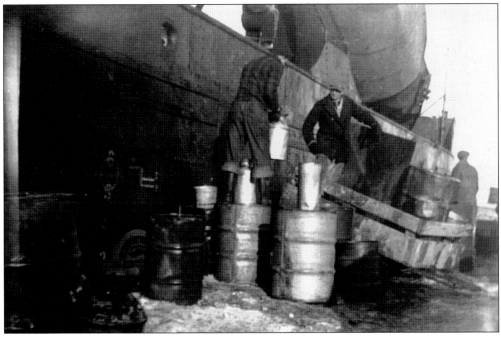

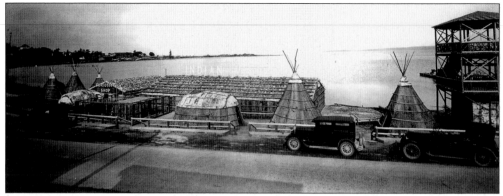

Clarence "C. C." Eby, opened Indian Village in 1927, located at the site where Fr. Jacques Marquette landed. Eby was a pioneer of the tourist industry. In the 1920s, he published several guidebooks about the straits area. Indian Village was a place to watch basket makers creating their handmade wares in open-sided birch bark lodges next to the store. The Indian Village continues to operate today. (Mark Eby.)

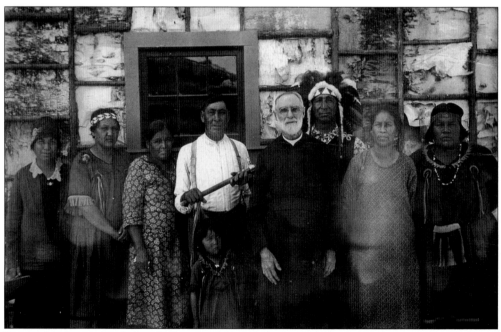

Pictured in front of an Indian Village birch bark lodge is Fr. William Gagnieur with local Native Americans. Gagnieur served at St. Ignatius Loyola Church from 1919 to 1926. Gagnieur was a recognized missionary priest and scholar. Gagnieur served not only in St. Ignace but also in the lumber camps. He participated in the annual Marquette Pageant, which later became known as the Black Gown Tree Pageant. (Mark Eby.)

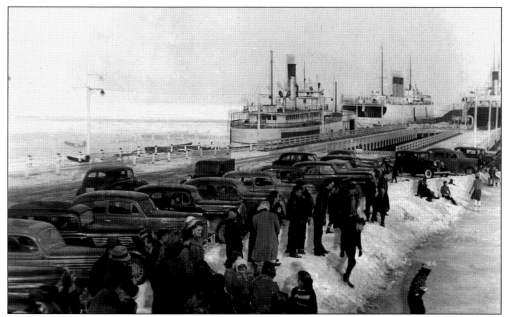

On the right, ice-skaters head down to the skating rink, while onlookers watch. The municipal department had previously flooded the parking lot at the present marina to create a skating rink. In the background, *Sainte Ignace* and *City of Munising* ferries wait in storage at Michigan State Ferry Dock No. 2, until the ice thaws (around 1938–1939). (Michilimackinac Historical Society.)

The St. Ignace Golf and Country Club was organized about 1926 and developed in the late 1920s–early 1930s. This log clubhouse was built in the late 1920s. After passing through several state and county ownership entities, in 1948 the nine-hole course became the City of St. Ignace's. The log clubhouse was razed about 1998, except for the chimney, which was kept as a reminder. (Ollie Boynton.)

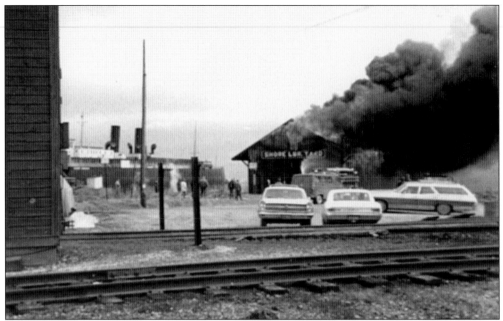

The Shore Lumber Yard, owned for many years by George Shore, was located on the merchandise dock on the waterfront in downtown St. Ignace. After Shore's death in 1962, the lumber company went out of business. In May 1969, the St. Ignace Fire Department destroyed what remained of the building in a controlled burn that was part of a beautification effort for the town. (Marge Robinson.)

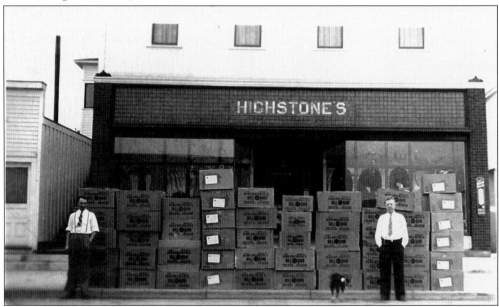

Leonard Goudreau (left) and A. R. "Bert" Highstone stand beside boxes in front of Highstone's Department Store. Siegfried Highstone established the first department store in St. Ignace in 1879. The Highstones were a prominent family, also operating an opera house and a garage. A. R. Highstone served as mayor from 1922 to 1928 and from 1951 to 1952. Warren, the third generation, built a new store in 1956. (Ollie Boynton.)

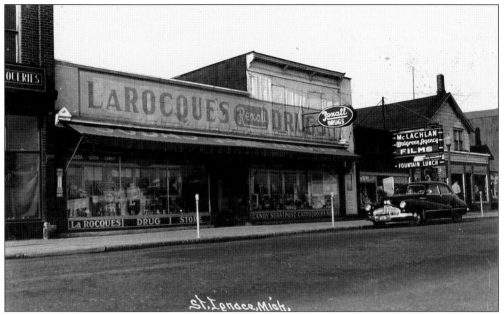

LaRocque Drug Store was one of the pioneer businesses in St. Ignace. The store was originally three buildings; it merged into one in the 1880s. Eustache and Leo LaRocque ran the store for many years. James LaRocque acquired the store in 1948. His wife, Dorothy, and son, Billy, owned the store after his death. They hired Bob Leveille to manage the Rexall store. (Tom Pfeiffelmann.)

This photograph was taken in 1936 at Saul's Ben Franklin store. This store replaced the Saul's store that burned in 1935. Pictured are, from left to right, three unidentified women, owner Saul Winkelman, employee Sylvia Hill Carlson, Marvin Winkelman, Mae Winkelman (Saul's wife), employee Alice Larson Thompson, and customer Aunt Jane Goudreau. (Marv Winkelman.)

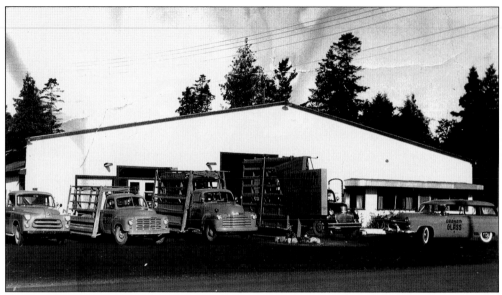

Graham for Glass Company was located at the present site of Huskey's garage on Business Loop Interstate 75. Carl Graham owned the business during the 1940s into the mid-1950s. He did many storefronts and other projects before selling to Marvin Gitchell. Terry Smith worked for Graham for Glass from 1956 to 1964. A few years later, Terry ran his own business out of the building, calling it Terry's Glass Service. (Terry Smith.)

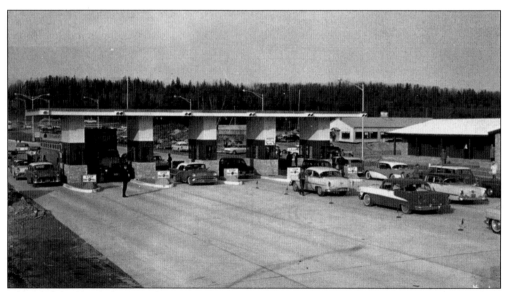

This is the official opening day for the Mackinac Bridge, November 1, 1957. Gov. G. Mennen Williams paid the first crossing toll of $3.25. The toll plaza originally consisted of five booths, which accommodated six lanes of traffic. At the far right is the Mackinac Bridge Authority Administration Building. The south portion of this building was faced with Drummond dolomite stone in 1957. (Vic and Mary Swiderski.)

Five

AFTER THE BRIDGE

In May 1969, Sandy Gustafson Harwath and Janice Steiner added the feminine touch to the spring cleaning maintenance on the Mackinac Bridge by helping Mel LaChapelle change the globes. As can be seen, they decided stretching was better than climbing onto the cables. Maintenance is a constant for bridge employees. (Michilimackinac Historical Society.)

"The Black Go[

The Black Gown Tree ceremony became a yearly pageant in 1949, reenacting the arrival of Fr. Jacques Marquette to the shores of Lake Huron in 1671. The Native Americans observed that he was dressed in a black gown and held up "a small tree with a man upon it" (a crucifix) with his hand raised in peace. There had been fur traders in the area, but Marquette was the first white

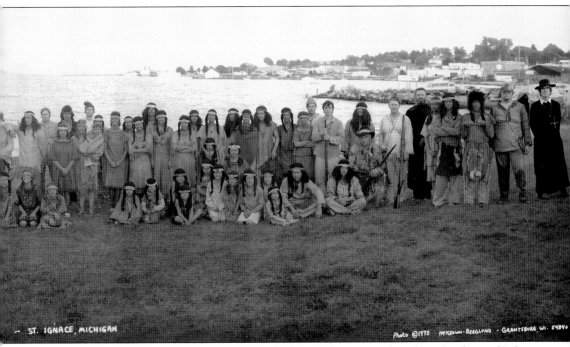

ST. IGNACE, MICHIGAN

Photo ©1975 McKEOWN-BERGLUND - GRANTSBURG, WI. 54840

man to live among the Native Americans. He built a crude mission chapel on the shore of Lake Huron to serve the Hurons and Ottawas, called Sainte Ignace, French for St. Ignatius of Loyola, founder of the Jesuit religious order. This pageant used many community members as reenactors and took place at Kiwanis Beach. (Mary Lou McKinnon.)

Isabelle Hagen was one of three nurses who worked at the bridge during construction. Other nurses were Helen Kalmer and Phyllis Tuck. They were the only women allowed on the bridge, except for official inspection parties. In 1954, Hagen courageously entered a decompression chamber for 24 hours, in an attempt to save Frank Pepper, lead diver, from the bends. Pepper was the first of five bridge-building fatalities. (Sue Huffman.)

Marion Brown, wife of Prentiss M. Brown (chairman of the Mackinac Bridge Authority), did the honors in the groundbreaking ceremony for the Mackinac Bridge on May 7, 1954. This great celebration ended years of effort to join the Upper and Lower Peninsulas of Michigan. In the center is a sighting tower for bridge construction. At the far right is a portion of the causeway built in 1942. (Marge Robinson.)

116

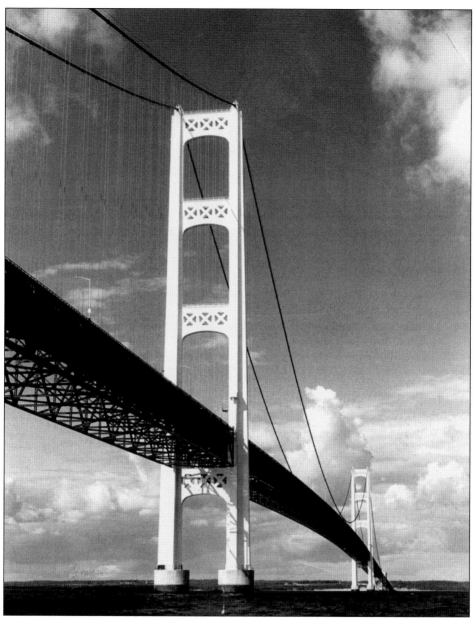

This 1958 photograph was a prize winner in an early Mackinac Bridge photograph contest. With this view from the waters of the Straits of Mackinac, local photographer Ronald J. Wilson was the first-place winner. Wilson snapped the gleaming 552-foot towers looking up from this new perspective. Early mention of a way to span the straits was made in the 1880s; mentally pictured was the then-new Brooklyn Bridge. Another solution was a series of bridges hopping from Cheboygan to Bois Blanc Island, Round Island, Mackinac Island, and finally St. Ignace. Alternative thinking produced the idea of underwater tunnels. Proceeding to build a bridge at the straits was daunting and over-whelming considering that it seemed to be impossible to build because of the water depth, fast currents, high winds, thick ice, lake bottom unknowns, and prohibitive costs. The beauty and majesty of the Mighty Mac made the wait worthwhile. (Michilimackinac Historical Society.)

For much of his life, Prentiss M. Brown (1889–1973) had a dream—to see the joining of Michigan's two peninsulas. He pursued a career in law, was elected to the United States Congress and the United States Senate, and became chairman of the Mackinac Bridge Authority in 1950. His determination to see his dream through, against all opposition, brought the magnificent Mackinac Bridge to all. (Michilimackinac Historical Society.)

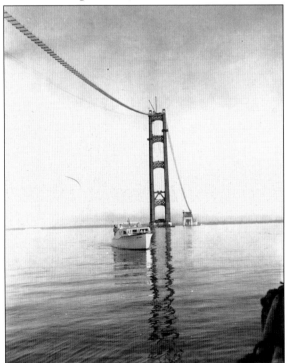

The Mighty Mac opened on November 1, 1957. The media called it "Michigan's biggest historical event in 100 years." Gov. G. Mennen "Soapy" Williams predicted the bridge would add $100 million to the state's economy. The bridge has changed St. Ignace. Railroad service and car ferries are gone, and many businesses are open only during tourist season. Still the historical past and beauty of the area bring visitors across the bridge. (David Walker.)

In early June 1960, Sen. John Fitzgerald Kennedy flew into Pellston Airport to ask Michigan governor G. Mennen "Soapy" Williams (left) to support him as the presidential nominee at the upcoming Democratic National Convention. They crossed the Mackinac Bridge and took a ferry to Mackinac Island, spending several hours at the governor's summer residence, meeting with other Michigan Democratic leaders. (Michilimackinac Historical Society.)

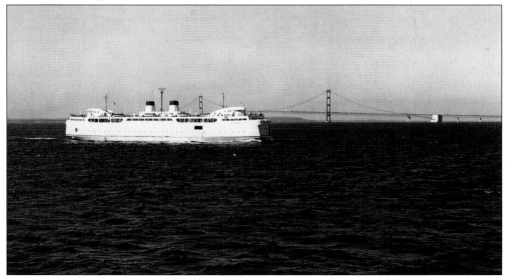

The last new Michigan State Ferry *Vacationland* arrived at St. Ignace on January 12, 1952. She used Michigan State Ferry Dock No. 3 (former Martel Furnace site), the only state dock big enough to accommodate her 360-foot length. The gleaming white double-ended ferry and icebreaker could transport 150 automobiles on each trip. October 31, 1957, was her last trip (above) because the Mackinac Bridge officially opened the next day. (Michilimackinac Historical Society.)

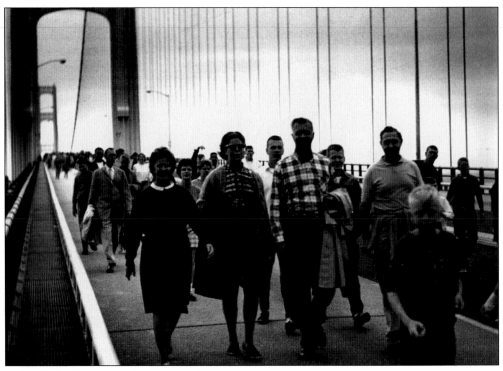

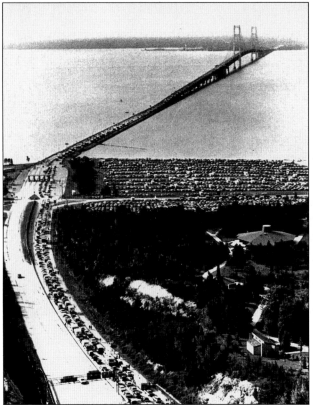

The first bridge walk was on June 25, 1958; 60 people traveled south to north. Labor Day was then chosen for the annual trek and participant numbers rose: 500 in 1960, 4,000 in 1963, and 15,000 in 1968. The walk's direction had alternated through 1964, then locked into a north–south path. In the foreground above are Gov. "Soapy" Williams (center) and Lawrence Rubin (right), executive secretary of the Mackinac Bridge Authority (1950–1984). This early bridge walk photograph (below) looks over the Fr. Marquette National Memorial, before Bridge View Park was built. In July 1960, four circus elephants even got to take a short stroll on the bridge. (Mackinac Bridge Authority.)

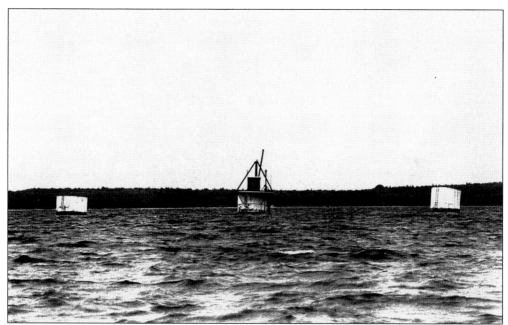

These caissons in Moran Bay were part of a jet fuel delivery system for Kincheloe Air Force Base. This military base, operating from 1943 into 1977, served Alaska-bound aircraft. Tanker ships moored at the caissons, originally topped by a platform. Jet fuel passed through a short pipeline to storage tanks on the nearby shore. Later it was pumped through a pipeline to Kincheloe, 37 miles north. (Michilimackinac Historical Society.)

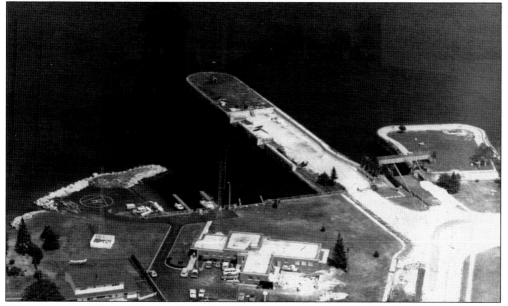

Construction of United States Coast Guard Station St. Ignace began in 1966 on the Martel Furnace site, after its previous presence on Mackinac Island. The Coast Guard is charged with maritime law enforcement, search and rescue, homeland security, and servicing aids to navigation such as buoys, lighthouses, and channel lights. Since 1979, the 140-foot icebreaker *Biscayne Bay* has been stationed here. (Coast Guard Station St. Ignace.)

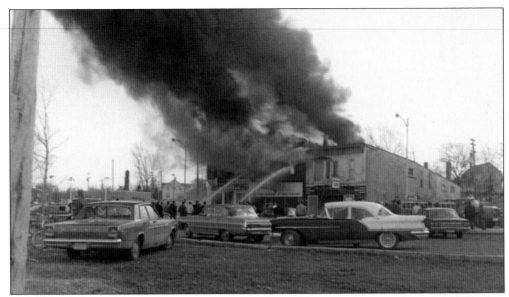

On Easter 1966, a small fire started in the Gamble's Store at the corner of State and Truckey Streets. The fire soon got out of control with all the paint, varnish, ammunition, and other combustibles. Despite valiant efforts by the St. Ignace Fire Department, three buildings were burned to the ground: Gamble's, the Fashion Shop, and Hub Restaurant with the Masonic temple on the second story. (St. Ignace Fire Department.)

The firemen hold a banquet each October. In 1967, the firemen attending are, from left to right, (first row) Toivo Hill, Bill Lambert, Howard Schlehuber, Gerald Brown, Ray Bo Grondin, and Joe Zagar; (second row) Chief Leonard St. Louis, Glen Doner, Clyde Savard, Joe Gill, Bob Belonga, Merle Utter, and Stan St. Louis; (third row) Jack Winters, Jim Fitzpatrick, Russell St. Louis, and Fred Moore. (Ollie Boynton.)

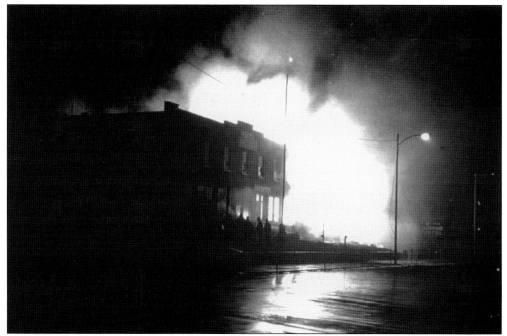

On Memorial Day evening 1961, at about 11:00 p.m., the Nicolet Hotel (formerly Hotel Northern) began burning. The fire spread and burned nearly all night in spite of the firefighters' efforts. The only part saved was the adjacent steel laundry building. Across from Michigan State Ferry Dock No. 2, the Nicolet had a bar, two dining rooms, and a huge lobby. (Ollie Boynton.)

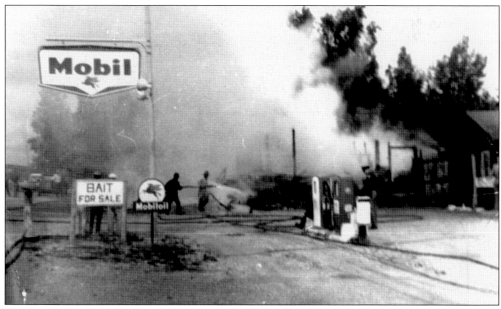

On August 30, 1963, Soeltner's Service caught fire and burned to the ground. Herb Soeltner, an automobile mechanic, opened the garage in the 1950s in Evergreen Shores near Chewamagon Hall (a popular spot for dances and roller-skating). At the time of the fire, Joe Davis had a 1957 Chevrolet in the garage for repairs. It was completely destroyed. (St. Ignace Fire Department.)

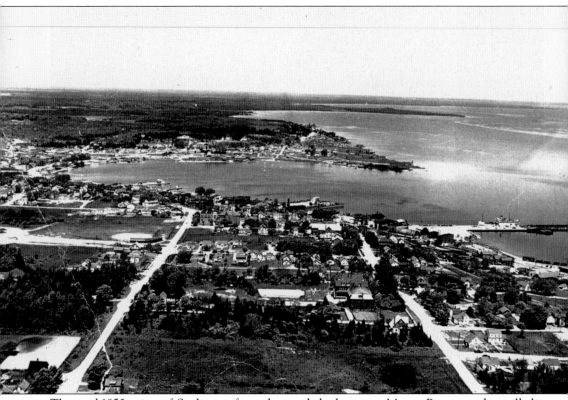

This mid-1950s view of St. Ignace from the south looks across Moran Bay, over the mill slip to Rabbit's Back peninsula. The next water north is Horseshoe Bay, and just visible is Grosse Point, almost on the horizon. Midway up on the right is Michigan State Ferry Dock No. 2, now the site of the St. Ignace City Marina. The train just below that is heading toward the railroad dock (out of sight). The two streets heading north are Church Street (on right) and Chambers Street. The Convent and Catholic school stand out on Church Street. The entire LaSalle School still remains at the corner of Chambers and Spring Streets. The large white roof just beneath Michigan State Ferry Dock No. 1 is St. Ignatius Loyola Church. The athletic field is on Chambers Street between McCann and Truckey Streets (Spring Street does not go through past Chambers). In the foreground, Keightley Street does not cross Church Street, going toward the Catholic cemetery. (City of St. Ignace.)

In 1969, the citizens of St. Ignace elected a commission to draft a new charter to replace the fourth-class-city charter. The commission met for six months using charters from other communities for reference. The commissioners from left to right are (first row) Paul Allers, Bob Belonga, Billy LaRocque, and Ollie Boynton (chairman); (second row) Harry Lee, Jack LaChapelle, Warren Hagen, Roy Bell, and Leonard Tromblay. (Ollie Boynton.)

The Rickley family, around the 1970s, partakes in the Ghost Feast. This native ritual honors the dead by eating for those who have passed and is celebrated from October 31 to November 8. The belief is that the spirits of the dead survive in nature and become hungry. The food eaten becomes their nourishment. In turn, the dead use their powers to enrich the lives of the living. (Michilimackinac Historical Society.)

SILVER LAKE EXPRESS "TRAIN RIDE"
St. Ignace, Michigan

For many years, children and adults enjoyed riding on Emil Syverson's Silver Lake Express miniature railroad. This was one of the world's longest narrow-gauge train rides. Embarking at the depot on U.S. Route 2, the ride ran four miles through a beautiful hardwood and pine forest to Silver Lake and back. There were two locomotives: the 1861 *Old Timer* and the sleek *Silver Lake Express*. (Madeline Adie.)

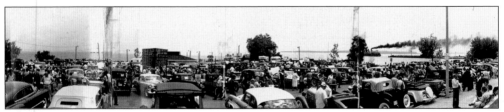

The first St. Ignace Car Show was held on the last Saturday of June 1976, with 134 vehicles displayed. The car show is a three-day-weekend event with an estimated attendance of up to 100,000. As many as 2,500 cars have been displayed all over the downtown area each year. This photograph shows an early car show. *Chief Wawatam* is in the background at right. (Ed Reavie.)

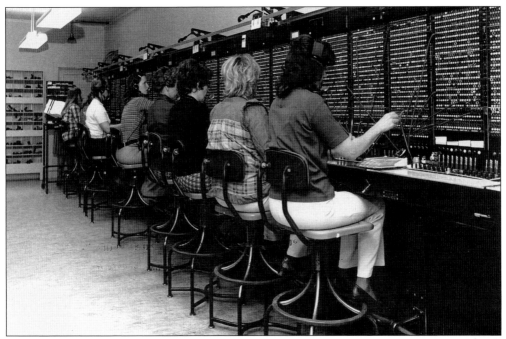

In 1893, W. A. Burt had the first switchboard installed at Wilbur Pharmacy, connecting 15 local-service-only telephones. The St. Ignace area had the last manual switchboards in Michigan (two others remained in the United States) when it changed to direct dial in 1974. Pemble's store had the last telephone number l in the country. The building below started out as the Michigan Bell building in 1938. When Bell vacated in 1976, it was donated for St. Ignace Historical Society's museum, until the historical society gave it to the city. In 1983, the St. Ignace Public Library moved out of the municipal building with its 10,000-volume collection into 6 Spring Street (below). The library was here until 2005, when it moved to Spruce Street. This building now houses the visitors' bureau and other offices. (Michilimackinac Historical Society.)

ACROSS AMERICA, PEOPLE ARE DISCOVERING SOMETHING WONDERFUL. *THEIR HERITAGE.*

Arcadia Publishing is the leading local history publisher in the United States. With more than 3,000 titles in print and hundreds of new titles released every year, Arcadia has extensive specialized experience chronicling the history of communities and celebrating America's hidden stories, bringing to life the people, places, and events from the past. To discover the history of other communities across the nation, please visit:

www.arcadiapublishing.com

Customized search tools allow you to find regional history books about the town where you grew up, the cities where your friends and family live, the town where your parents met, or even that retirement spot you've been dreaming about.